Strange Impressions

David Zwirner Books

ekphrasis

Strange Impressions
Romaine Brooks

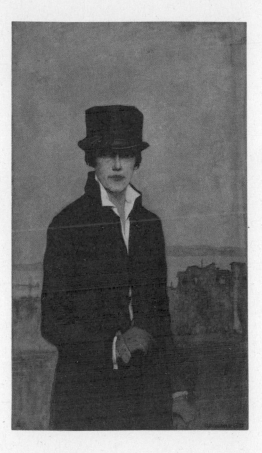

Romaine Brooks, *Self-Portrait*, 1923
Oil on canvas, 46 ¼ × 26 ⅞ inches | 117.5 × 68.3 cm

Contents

Editor's Note

Romaine Brooks began writing her memoir, "No Pleasant Memories," in the 1930s, and, to date, it remains unpublished in full. The selection here is taken from her original typescript manuscript, held in the Archives of American Art at the Smithsonian Institution. We have incorporated Brooks's own handwritten edits and otherwise have striven to respect her original text as close as possible. In order to not distract from Brooks's prose, we have not offered English translations of the French phrases and lines in the manuscript. In the chapter "First Exhibition," we have excluded from this volume, due to space considerations, a passage in French from an article on her work by Comte Robert de Montesquiou. In the chapter "The Portrait," we have also excluded from this volume the transcription of the poem by Gabriele d'Annunzio titled "A Romaine Brooks: Sur son portrait peint par elle-même." In the chapter titled after d'Annunzio's poem "Sur une image de la France croisée, peinte par Romaine Brooks," the transcription of the poem has been excluded. Brooks used both British and American spellings throughout her manuscript, and as an American publisher, we have standardized the use of American spellings in this volume. Additionally, in certain cases, we have made slight modifications to punctuation and capitalization to reflect contemporary usage and for greater consistency and readability.

Introduction

Lauren O'Neill-Butler

... I fear no country's ready yet
For our complexities ...
—Natalie Barney, "Love's Comrades," 1920

The American painter Beatrice Romaine Goddard Brooks (1874–1970) was born in a hotel in Rome to Ella Waterman Goddard, a peripatetic inheritrix who was slowly losing her mind. The artist's father, Major Harry Goddard, deserted his family not long after her birth— leaving his three children in a situation resembling "a court ruled over by a crazy queen," as Brooks recounts in the first chapter of her memoir, "No Pleasant Memories."[1] Brooks's mother went on to abandon the artist at least three times: at age six, when she left her in the care of their New York laundress, Mrs. Hickey; at thirteen, when she dumped her at a convent in northern Italy; and at seventeen, when she sent her to Mademoiselle Bertin's Private Finishing School in Geneva.

Brooks's 295-page typescript manuscript of "No Pleasant Memories" has sat in the Archives of American Art since the 1970s; before her death, she gifted her papers to the institution and many of her paintings and drawings to the Smithsonian American Art Museum. Brooks began writing the manuscript in the 1930s and revised it on and off in the decades following World War II. The selected chapters contained here—really, they are more like impressionistic episodes—provide a strong sense of her dynamic yet discreet writing style and voice, which,

unsurprisingly, is a lot like her self-described "stern" paintings: calm and crisp on the surface but psychologically complex upon further examination.

Generally, Brooks's role and influence in modernist circles of the early twentieth century have been woefully underrated. This publication is a necessary, timely corrective to show—*in her own words*—how she challenged social norms and the day's misogyny by providing heroic images of women sporting full dandy attire or standing on a World War I battlefield, branded with the international symbol of the Red Cross. Brooks was a harbinger of immense change in the arts at the turn of the century. Her vital work for visibility is essential to understanding how far feminism has come today.

This compendium highlights the decisive encounters and events that shaped her life and work. After her difficult childhood and education across several countries, with summers spent in her mother's various villas along the French Riviera, Brooks studied voice in Neuilly, France, and then prevailed upon her mother for a monthly allowance of three hundred francs, which (finally) granted her some economic independence. In 1898, Brooks went to Rome to study art. She rented a studio and studied in the evenings at the Circolo Artistico while also attending the Scuola Nazionale, briefly, as the only female student. In the summer, she traveled to Capri and rented a dilapidated chapel for twenty lire a month. The island, then a refuge for gay men and lesbians, became a haven for her—one she longed for most of her life.

After the death of her brother, St. Mar (which she spells St. Amar in her manuscript), and then her mother, in 1902, Brooks became independently wealthy and moved to St. Ives in England to paint. She rented a small studio and began creating finer gradations of gray for her paintings—scholars have compared this nascent palette to James Abbott McNeill Whistler's tonalist, Gilded Age–era canvases. When a group of local artists asked Brooks to give an informal show of her work, she displayed only some pieces on cardboard onto which she had dabbed her experiments in hue. She considered it a success. From then on, nearly all her paintings were keyed to a gray, white, and black color scheme with touches and tints of ocher, umber, alizarin, and teal.

In 1905, Brooks established herself in the openly queer circles of Paris with a luxurious apartment on the present avenue du Président Wilson. She studied with Gustave Courtois and quickly became part of the Parisian haut monde. She embarked on a fruitful path as a portrait painter of some of the city's most gifted denizens—including her longtime lover, the American playwright Natalie Barney; the British poet Renée Vivien; the Russian dancer Ida Rubinstein (Brooks's most inspiring muse); and the French poet Jean Cocteau. Each receives a chapter in "No Pleasant Memories," though the intimate details of her relationships with the women are not disclosed.

Perhaps that was because, at the time of her writing, both Barney's and Brooks's prosperities and paramours

were beginning to figure in novels by their colleagues. For instance, Barney appears in Liane de Pougy's *Idylle saphique* (1901), Radclyffe Hall's *The Well of Loneliness* (1928), and Lucie Delarue-Mardrus's *L'Ange et les pervers* (1930), while Brooks is featured in Hall's *Adam's Breed* (1926) and Compton Mackenzie's satiric *Extraordinary Women* (1928). Several decades later, similarly sensationalized accounts of both women appear in Meryle Secrest's *Between Me and Life: A Biography of Romaine Brooks* (1974) and Jean Chalon's *Portrait of a Seductress: The World of Natalie Barney* (1976). More recently, Diana Souhami's *Wild Girls: Paris, Sappho, and Art; The Lives and Loves of Natalie Barney and Romaine Brooks* (2004) and Cassandra Langer's *Romaine Brooks: A Life* (2015) have voyeuristically overemphasized their intimate affairs. Repeatedly, as Bridget Elliott and Jo-Ann Wallace have noted, in such chronicles it is their lives—as opposed to their work—which are constructed as "enduring artifacts."[2]

The consummate dandy, Brooks was also clearly a private person, and "No Pleasant Memories" is deeply enigmatic. Her fleeting *mariage blanc* in 1903 with the gay English pianist John Ellingham Brooks is not discussed in the book, nor is he mentioned by name—only as "Mr. G." in "The Walking Tour," wherein she discusses their falling out after he was "horrified" by her sporting outfit of baggy trousers and Eton crop haircut. She concludes that while she would have no help from him in her "efforts to escape the conventional," she "could but

choose to face the future alone"—which was her pre-ferred mode, anyway.[3] Though she was guarded, Brooks was also dedicated to living, and perhaps more impor-tantly documenting, a consequential life.

One of the strongest themes to emerge in both her paintings and writings is how she self-consciously con-structed herself as an outcast and member of *les lapidés* (victims of stoning). "My mental outlook was that of one who had always had to struggle," as she claims in the (dryly titled) chapter "Friends."[4] In "La Flora," after snubbing a marriage invitation from "a young English painter" who also goes unnamed, she writes, "I was per-plexed and certainly amused. It was clear, however, that I could not speak to my unsophisticated friend about such things as: the determination to remain outside the circle of conventions; the disdain felt for the protected ones within that circle. Did I not consider myself as one of *les lapidés*?"[5]

Even her greatest contemporaries were not to be trusted. In "La Tour Eiffel," a chapter on her portrait of Cocteau set against the titular landmark, she discusses her fruitless friendship with him, noting that he was "no *lapidé* ... he sided with those who threw the stones."[6] Brooks was skeptical of artists she deemed to be *arri-vistes*. In "A Stranger," she argues, "Even success as an artist was in my opinion a form of compliance; it held down and bound one to what should have served merely as a means of escape." To this end, she saw herself as "a stranger everywhere."[7]

To be sure, she was an outsider when it came to the day's reigning misogynist social norms, and she was aware she could be punished for her open sexuality. Nevertheless, she persisted. In *The Paris Review*, Truman Capote recounted his visit with Barney in the 1940s to see Brooks's paintings:

> And Miss Barney said, "This is the studio of my be-loved friend, Romaine Brooks," and I'm quoting that just exactly—"my beloved friend, Romaine Brooks," and we began moving around the room and she would pull the cords and the cloth would slide back from these paintings and there they were: Lady Una Troubridge with a monocle in her eye; Radclyffe Hall in a marvelous hunting outfit with a terrific hunting hat. It was the all-time ultimate gallery of all the fa-mous dykes from 1880 to 1935 or thereabouts.[8]

To be producing such brave and brazen works during world wars driven by macho-fueled hate and greed was a major accomplishment.

Unfortunately, Brooks was sometimes on the wrong side of history, like many of her upper-crust colleagues at the time. In 1909, Brooks met Gabriele d'Annunzio, an Italian writer who had come to France to escape his debts. She saw him as a martyred artist, another *lapidé*. He also influenced her attraction to Italian Fascism and Mussolini. Langer's biography astutely addresses this (and Brooks's inexplicable anti-Semitism). She writes,

"In order to understand what led Brooks to side with Fascist Italy and move there during World War II, it helps to understand her elitism, her pacifism, her political immaturity, her bigotry, and her conviction that Italy would not involve itself in another war. Above all, it helps to understand her love for Natalie Barney."[9]

Brooks and Barney were radical in some ways but not in others: they desired visibility as lesbians but were not interested in politics or changing laws. Their personal, political, and aesthetic choices should be understood in terms of their vast privilege and class, even while they resist easy classification as "conservative" or "radical." In a similar way, it would be erroneous to say that Brooks was "conservative" as a modernist because she worked in traditional modes of portraiture and not newer styles, such as impressionism or cubism. Hers was a much more complicated personal project of artistic freedom, which she was able to achieve in Paris. Brooks's vanguard contribution of placing gender and androgyny at the forefront of her art distinguishes her work from that of previous periods, and most certainly from that of Picasso. (As he used to say of Gertrude Stein and her circle: "Ils sont pas des hommes, ils sont pas des femmes, ils sont américains.")

Throughout "No Pleasant Memories," Brooks presents herself as a martyred and resilient woman—despite her horrendous upbringing and the post-traumatic stress it caused. She was determined not to be broken by her brother's illness and mother's cruelty. Long before Andy

Warhol perfected the artistic craft of self-creation—though around the same time that Stein pioneered radical autobiographical strategies—Brooks worked diligently at refining her persona and personal mythology. She retained a keen understanding of the role clothing and style play in creating a character. Her expertise in self-portraiture and self-fashioning may have even helped her to heal her childhood traumas.

Consider her confident presence and direct gaze at the viewer in her *Self-Portrait* (1923; p. 5), which is perhaps her most famous work. Dressed in a riding hat and coat, Brooks chose a chic, genderless look for this well-crafted image. At the same time, her powdered, shadowy face suggests a carefully constructed facade, and the dark, dilapidated buildings in the background may allude to her family—another ruin of sorts. In *La France Croisée* (1914), Brooks employed a similarly dismal background, of the Belgian city Ypres burning during World War I. Here, Rubinstein is depicted as a saintly Red Cross worker, a true heroine. For her wartime work such as this, Brooks earned a Legion of Honor medal from the French government in 1920. The flash of red in her lapel in her *Self-Portrait* is a reference to this accolade.

These canvases, and many others by Brooks, should be recognized as operating within a larger project of feminist and queer visibility. For this, Brooks needed to imagine herself and her subjects from a perspective that emphasized identity, but in a format that could be socially recognized and praised. While this approach was

profound at the time, it's also important to acknowledge that Brooks created her portraits as a way of maintaining class and social status. She did not travel far outside of her elite social circles for subjects to paint, and in "No Pleasant Memories" it becomes clear she both loved and loathed those circles.

Throughout her life, Brooks never conformed to the day's reigning styles or movements. This was true from her debut as an artist. In the chapter titled "First Exhibition," regarding her earliest solo show, which was held at the Galerie Durand-Ruel in Paris in May 1910, she makes this abundantly clear: "I grasped at every occasion no matter how small to assert my independence of views. I refused to accept slavish traditions in art."[10] During the same year of her show, the gallery exhibited works by Manet, Monet, Pissarro, Cezanne, Renoir, and Cassatt. Brooks's presentation was enormously successful and opened to many positive reviews in the press. She covered the gallery's plush red walls with pale beige fabric and presented thirteen of her naturalistic paintings, almost all of women. Some were portraits of members of high society flaunting Belle Epoque fashion (parasols, veils, and elaborate bonnets); others depicted anonymous models in interior scenes or set against almost monochromatic backgrounds, often with contemplative expressions.[11] In each work, Brooks captured the mood, and often the despondency, of her subjects. The French aesthete and aristocrat Robert de Montesquiou wrote an appreciation calling her "the thief of souls."

Notably, Brooks included two nudes in this exhibition—
The Red Jacket and the more candid and erotic *White Azaleas* (both 1910)—a highly provocative choice for a woman at the time, which also set the theme of lesbian desire in her work to come.

While Brooks was known as a mannered, "stern," and somber painter, some of her portraits, such as her 1920 canvas of Barney, are symbolist. Here, Barney is depicted with a sculpture of a small dark horse (a gift from Brooks), which alludes to the sitter's insistence on freedom. Brooks was also a gifted draftswoman. She made more than one hundred drawings consisting of a single unbroken line in the 1930s while writing "No Pleasant Memories." Recalling contemporaneous surrealist automatic drawing in their portrayals of conflict and fantasy, these are some of her most captivating works, and they relate directly to scenes in the book—whether an image of St. Mar protecting her from spirits or a sorrowful picture of departure. The drawings were exhibited in 1935 at the Arts Club of Chicago, and in the accompanying exhibition catalogue, the artist commented, "These drawings should be read. They evolve from the subconscious. Without premeditation they aspire to a maximum of expression with a minimum of means."

"No Pleasant Memories" ends abruptly in 1918, at the end of World War I.[12] By the book's close, Brooks makes it clear that she was grappling with a "new barbaric fighting world," which was "detaching us from an old familiar world."[13] The final painting she discusses is her se-

date canvas *Weeping Venus* (1917; pp. 22–23). This nude was modeled on photographs Brooks took of her greatest inspiration: "Who other than Ida Rubinstein with her fragile and androgynous beauty could suggest the passing away of familiar gods," she concludes.[14] While Brooks saw this portrait as commemorating a lost past, to me, it sings out as an emblem of the feminist and nonbinary future.

1 See p. 27 in this volume.

2 Bridget Elliott and Jo-Ann Wallace, "Fleurs du Mal or Second-Hand Roses?: Natalie Barney, Romaine Brooks, and the 'Originality of the Avant-Garde,'" *Feminist Review*, no. 40 (1992): p. 11.

3 See p. 108 in this volume.

4 See p. 68 in this volume.

5 See pp. 58–59 in this volume.

6 See p. 132 in this volume.

7 See p. 135 in this volume.

8 George Plimpton, *Truman Capote: In Which Various Friends, Enemies, Acquaintances, and Detractors Recall His Turbulent Career* (New York: Anchor Books, 1998), p. 85.

9 Cassandra Langer, *Romaine Brooks: A Life* (Madison, WI: University of Wisconsin Press, 2016), p. 160.

10 See p. 125 in this volume.

11 For more on this show, see Whitney Chadwick, *Amazons in the Drawing Room: The Art of Romaine Brooks*. Exh. cat. National Museum of Women in the Arts, Washington, DC (Berkeley: University of California Press, 2000), pp. 18–19.

12 The book's abrupt conclusion might be attributed, in part, to her second unpublished manuscript, "A War Interlude, or On the Hills of Florence during the War," which is also held at the Archives of American Art. Here, she mainly discusses her life with Barney in Italy during World War II.

13 See p. 175 in this volume.

14 See p. 175 in this volume.

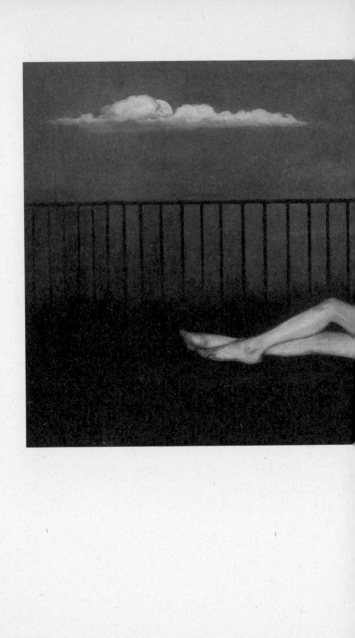

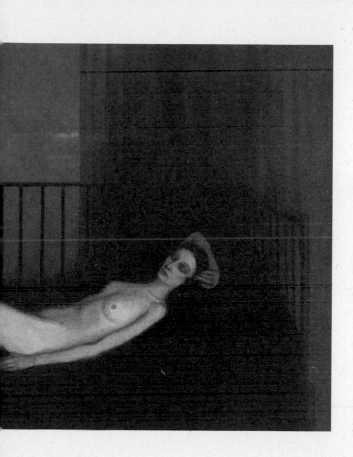

Romaine Brooks, *Weeping Venus*, 1917
Oil on canvas, 67 × 102 ⅜ inches | 170 × 260 cm

Strange Impressions

Romaine Brooks

To be caught in the vicious circle
of another's life is to revolve
perilously in another's perils.

Were I to consider the conventional relationship be-
tween parent and child, these memories would become
a chain of invectives both biased and unjust. Personal-
ity is more important than relationship when it exists to
the degree that was realized in my mother, and though
recalling my particularly unhappy childhood, I hope to
do part justice to her memory.

A certain French lady, on being asked if it was true
that she disliked her son, answered: "La naissance est
une double indiscrétion." This answer, equivalent to
a mutual criticism, should, by virtue of its frankness,
amend what might at first seem unmendable. As soon
as I could make any effort at all, I made them in this
direction.

Why blame the cause of past tribulations if their ef-
fect in the present stands for strength and individuality?
It pleases me rather to survey objectively the plant that
survived the storms of that atmosphere of intense and
adverse feeling.

That my mother stands apart from these consider-
ations is obvious, since her hatred, like her love, built
up a consciousness beyond law and reason.

She was, at the time of my birth, beautiful, autocratic,

and highly cultivated. Expressing herself in the Romantic lyricism of her time, she wrote:

> The lightning, the lash of wind,
> But spur the soul; the storm calls wild,
> The shackles of men's fate unbind
> A lover from lost worlds exiled!

Later, she turned to mysticism, and her mental flights bordered on madness.

> 'Twixt you and me and other worlds
> Oh, demon of destruction,
> We seek to find our double selves
> Lost in Death's constellations.

Perhaps the hate of such a personality could prove more beneficial than her love. It provided the occasion for showing strength in opposition; for holding firmly to what she did not represent; and finally for bringing to bear judgment against the injustice of her tyranny.

My brother, whom she loved, was easily swept into the turmoil of her existence. As his congenital weaknesses were not discouraged, they developed, as time went on, into serious disorders.

In the confusion about her my mother created an atmosphere of continuity which made no distinction between night and day. Indeed, she had no consideration for Time and would have banished it altogether.

She rarely slept during the night and *never* went to bed. Her meals were served at any hour of the day or night, and sometimes, by her orders, they were not served at all. Those in her immediate circle could but follow her example and accept the dictates of her eccentricities. Fortunately there were times when she was quite lost to the world, and these were our most pleasant moments. She would converse with herself, or rather with invisible friends, and for such intercourse her most gracious manner, reserving for this world alone the incessant irritability of her other moods.

Yet, in all this confusion, my mother always impressed everyone with the sense of her immense importance. Perhaps this could be accounted for by her arrogance, unusual culture, and personal elegance. The atmosphere she created was that of a court ruled over by a crazy queen; and before my brother showed definite and incurable signs of madness, she treated me either as one of royal blood—since I was descended from her— or else as a page-in-waiting rather than a little girl. There was even a time when she dressed me up in replicas of the clothes my brother had worn as a very small boy. But she never failed to remind me that I was not good-looking like St. Amar, and indeed, my pale face and dark hair could in no way compare with his angelic blondness.

With all this she insisted on being treated with the greatest respect, and so to this day I am inclined to show to others a courtesy in no way consistent with my age or sex.

Between the ages of six and seven a change took place in my life, and this is how it happened: My brother had been absent for some time undergoing a cure. This proved ineffectual and it accounts for my mother's embittered attitude toward me. I would feel her eyes fixed upon me with such a hostile expression that it was evident that she was devising some plan to punish me for being in good health while St. Amar was incurable.

Looking back upon this time it is hard to make allowance for the many miseries I had to endure. One day my mother's maleficence came to a climax. Dragging me into her room, she pulled off my velvet jacket; then, in order to make me as ugly as possible, chopped off my hair in all directions with a pair of scissors.

I remember well this incident because it was followed closely by my rescue (so it seemed to me then) by no other than my mother's washerwoman. Mrs. Hickey was her name. She had agreed with my mother to take me to live with her. One evening I placed my hand in hers, and without ever looking back at my mother, lying regally on her couch, I left the hotel to pass into the night toward a new life in the midst of New York's tenement quarters.

Mrs. Hickey was a stout, good-natured Irishwoman. She lived at the top of a high tenement building on Third Avenue. I remember the long drive in the tramcar, and then the seemingly endless climb up the dark staircase. Once in her rooms Mrs. Hickey asked me if I had had

my dinner. On my answering no, she fetched from the kitchen a slice of bread and butter and a large cup of black coffee. I had never tasted black coffee before but it was now to take an important place in my future meals.

I was put to bed on a sofa, and for the first time in many months I slept the whole night through. On awakening next morning I noticed how light the curtainless window made the room, and how strange the fire-escape balcony looked outside. I saw, too, that the walls were covered with crudely colored, combined cardboard pictures and frames which Mrs. Hickey's son had brought home from the shop where he worked as a salesman.

Mrs. Hickey called me into the kitchen, where I was given another cup of black coffee and a huge pancake. The very first day I managed to procure pencil and paper and a small drawer all to myself to keep these precious articles in. Mrs. Hickey said she would like a friend of hers to see my sketches and directed me to a window on the right of the fire-escape balcony. There I found a young man drawing at an easel. He seemed to be the only thing in the room not covered with heaps of fuzzy woolen mats. He told me that his mother made the mats while he copied photographs. I admired his copies and he in turn looked wisely at my drawings. We became very good friends.

Life now became an endless adventure. In time I even dared to descend the dark evil-smelling stairs, where from out of different doors queer, frowsy people darted up and down. On gaining the crowded street I would

walk on in a daze and very often lose my way, to be taken back home again by a policeman. Once, to see the trees, I walked to Central Park; it was so far off that when I reached it I was too tired to walk back again. Some passerby, seeing my plight, gave me a few pennies to take the streetcar.

All this was indeed a great change from the caged-in existence at the hotel with my mad family. I can even remember running about on roller skates in the treeless square near our street. How these skates happened to come into my possession I have now no idea, but what is certain is that, when they were broken, no others took their place.

One day while skating in the square, a respectable-looking old man who sat there regularly called me over and asked me to buy some collar-studs for him. The request was unusual, but as he gave me the money I brought them to him the next day. He seemed grateful and thanked me many times. I thought no more of the incident until later on when someone told me that he was "strange" and that children were warned not to approach him!

Though I adapted myself more or less to my surroundings, I was attached only to Mrs. Hickey, who was, I considered, my rescuer. I disliked her son Mike and also the swarms of children it was impossible to avoid meeting in the streets. At first they would surround me in groups, staring, then having decided that they liked me, would follow me about, much against my will. Little

boys and girls, the latter often wheeling perambulators, seemed attracted by the glamorous atmosphere which my comparatively fine clothes carried with them.

Later on, when my presence became even more familiar, they tried to make me join in their games. I had never played with little children before; and I had already noticed how rough these could be. Their victim was generally a small newcomer like myself whom they could place between them protectively. Then all joining hands they would run down the street, five abreast. Suddenly, at the height of the impetus, they would let go the hands of the innocent child who would then be projected forward on its face. I had no intention of passing through such experience and managed for a long while to evade them. One day, however, they promised so earnestly that they would hang on tightly to me, that I relented and found myself racing down Third Avenue between my captors. That they actually did hold on to me, and were afterward proud of the fact, must ever remain to their credit.

But to return to Mrs. Hickey, I felt that she had saved me from my mother and so my affection for her was colored with gratitude. But little did I realize how soon this gratitude was to be put to the test.

One afternoon, hearing a great commotion in the kitchen and looking in, I saw Mrs. Hickey's dejected form seated between two baskets heaped with clean linen. She was crying and moaning and rubbing up and down her poor varicose-veined legs. She had taken the linen as usual to my mother, but on arriving at the hotel she was

told that the lady had gone away without leaving an address. It was a tragedy. No money for the washing—her weeping, kindly eyes turned to me—and a child on her hands, unpaid for.

I was shocked, and my first impulse was to come forward and give the address of my grandfather's country house. I knew it perfectly well, but ... I also knew that it would mean going back to my mother. For the first time I stood alone and acted on my own initiative. Deliberately I remained silent, as children often do, and I effaced all memory of my life at Chestnut Hill. In perfect innocence I took my part in the general upheaval that was to follow.

My mother's neglecting to pay Mrs. Hickey brought about an astonishing series of calamities in that poor household. First of all, cheaper rooms had to be found; and this time they were on the ground floor, on the courtyard. There was one bedroom, a kitchen, and a sort of closet. The bedroom was for Mike. Mrs. Hickey, myself, and a frowsy relation—who also helped with the washing—slept altogether in the closet. I can still smell the odor of that shut-in pen—a mixture of unwashed bodies and beer. Mrs. Hickey and her relation drank a great deal of beer, and I was usually sent to fetch it from the "corner saloon."

No sooner were we settled in our new place than Mike was taken ill with fever. A nurse was called in, adding to the already overcrowded condition of the household. All night I would sit up with her in order to escape the bedbugs which infested the tenement house. I remember

the nurse's sympathy, and her holding me on her lap, sometimes, while I slept.

My real grief was caused by a tree in the courtyard. It was a melancholy specimen of its kind; Nature had long since abandoned it and its ugly surroundings. To me, however, it was a precious and beautiful tree, and I anticipated sitting quietly under its begrimed and scraggy branches. Alas! I was to know that all the children in the district had chosen that particular spot as a meeting place; the poor tree, fairly trembling with the clamor of their voices, failed to offer even the illusion of rural seclusion.

Mrs. Hickey would now go out to work for the whole day, leaving me a few pennies with which to buy food. I lived practically on some sweet buns. There were no more pancakes or black coffee. Hunger now became chronic, and I would rock myself violently in the rocking chair and sing loudly to ease the pangs.

One day it began to rain hard while I was playing outside. Running back to the room for shelter I found the door locked. This had never happened before. Wondering what it meant I put an eye to the keyhole. To my surprise I saw Mike in bed with the frowsy relation who helped drink beer and wash the clothes. I realized in some odd way that my indiscretion was unpleasant to me and quickly turned back again into the rain. Toward evening, entering the room with Mrs. Hickey, we found the woman still in bed, drunk; Mike had disappeared. Mrs. Hickey asked me if I had seen him, but I

disavowed all knowledge of his movements, probably because the incident had not fixed itself too agreeably on my mind.

During all this time, Mrs. Hickey never asked me to work, nor did she bother me in any way. Yet, understanding that I ought to make an effort, I tried to get a place in one of the big shops, but they found me too young. Then a small acquaintance of mine sold newspapers in the streets, and that seemed to me the height of achievement. She would divide her bundle with me, and I ran about selling them, crying out the news in a small piping voice. This was not unpleasant work; I do not remember why I gave it up.

The father of another small child I know wished to adopt me. He was a prosperous butcher in the neighborhood. He was greatly offended when I refused to leave Mrs. Hickey.

THE VISIT

One day Mrs. Hickey asked me to accompany her to the house of a lady for whom she was working. My hair was very short as was my frock also, and I imagined myself to be very ugly. Reluctantly I followed Mrs. Hickey to the lady's flat. We were shown into a large room filled with easels on which were the most astonishing pictures— embossed seascapes framed in velvet! The lady artist entered the room, kissed me, and gave me a handful of

gingersnaps. While she spoke to Mrs. Hickey I fearfully approached one of these pictures. It was a wreck; the waves and the drowning people were boldly embossed in the foreground. Afterward I was told that the subject was a most improbable one for a fancy picture framed in velvet. Be that as it may, the embossed picture of the wreck, the gingersnaps, and the lady artist all remain in my memory vivid parts of that particular visit.

A few days later a less pleasant event was to occur. I was out buying buns when someone told me to run home quickly. On opening the door I saw a gray-haired gentleman sitting in Mike's squalid bedroom. I recognized my grandfather's secretary. Silently we looked at each other. No doubt he was surprised and pained by what he saw. I was equally surprised, and worried at what I sensed was about to happen. I watched him take from a large pocketbook several banknotes. He handed them to Mrs. Hickey and asked her if the sum was sufficient. She thanked him volubly, her features taking on that unhappy expression of intense pleasure I have so often noticed on the faces of the poor. Then, my dirty hand in his, and without a hat, I walked out of the house with him.

Once in the carriage with Mr. Barr I asked him if I was to go back to my mother. He answered briefly that I was to be sent to school, but that in the meantime a lady, a friend of his, would clean and dress me. This lady proved most enthusiastic about her task; she had me scrubbed first, then arrayed in the most expensive clothes she could find. The frock was of lace over a silk slip; the hat

was a wonder of cream Italian straw, black velvet ribbons, and an ostrich feather. What my particularly small thin face looked like under that important structure is hard to imagine. But I was not at all pleased; I missed Mrs. Hickey. I must have confided as much to the lady for she decided to send me to visit Mrs. Hickey for the day.

Dressed up in all my new finery, my reentrance into slumland was a triumph. All the tenement children suddenly became my friends again, and as it was Sunday, I was escorted to Sunday school by an admiring bodyguard. There it happened to be a special day for signing the drink pledge. I remember solemnly signing my name along with the others.

At Mrs. Hickey's the tenement mothers had assembled. As they fingered my finery they all declared that the outcry against me had been a terrible mistake!

THE CONVENT

They try to measure God,
but only end in measuring their
own coffins.

R.

My mother had never forgotten that the authorities at St. Catherine's had baptized and confirmed me without her consent. As I was on the point of a nervous breakdown, she thought of an excellent plan which would not

only give me a change (and a not too agreeable one at that) but also create the occasion for retaliation.

We were staying in a town in northern Italy, and no better place could be found at that time for choosing an exceptionally strict convent to which I could be sent and eventually converted. Accordingly the day arrived when, with a small trunk containing clothes specially bought for the occasion, I was taken to a convent and left there to adapt myself as best I could to a life of medieval Catholicism.

THE MOTHER SUPERIOR

The Mother Superior was expected in the reception room. I had been told that this aristocratic and important personage would expect me to advance and make a curtsy. There seemed no difficulty in doing this since my mother demanded an even greater show of respect from me. But when the Mother Superior entered the room I stood motionless with surprise. Never had I seen anyone so amazingly ugly! The monstrous yellow face framed by the ruche of a small gray bonnet, the great flabby mouth falling over a stiff black-and-white bow, brought to mind stories of ogresses read about at St. Catherine's. It was clearly my fate to live with the mad and irresponsible, and this new monster was evidently needed to continue the nightmare of my childhood.

Bewildered, and feeling far from reassured, I followed

a nun who had come to take me in charge. She led me into a large dormitory filled with beds. One of these was to be mine, together with a chest of drawers at its foot.

The nun opened my trunk and I was impressed by the oddity of the garments she drew out. The combined chemise nightgown of thick linen, with long sleeves and high neck, was, she told me, to be worn night and day in order to prevent any display of anatomy when getting in and out of bed. It was discreetly changed every Sunday, and this I found out later was to be no easy matter, for the clean one had to go on before the other was off. There were also long black stockings in the trunk and among them I saw what seemed to me a particularly ugly green pair. My nerves were evidently in a bad state for after declaring that these stockings were impossible to wear, I, who never cried, began crying.

The sister, although not unsympathetic, made me understand that whatever came out of the trunk would have to be worn. Then taking off my short skirt she put me in a one-piece affair of black-and-white checks. This garment reached the ankles and modestly covered the neck and wrists—all for the good of my soul I was told. My hair, which fell over my shoulders, was twisted into small plaits and tightly pinned to form an ugly bun at the nape of the neck. My fringe was parted in the middle and plastered down in order to show the forehead.

Thus transformed I was taken to the refectory where I found some two hundred little girls dressed exactly like myself. After a long prayer we sat down to a bowl of soup

dished from out a huge black cauldron which a sister wheeled into the room. Perched high in a pulpit another sister read aloud while we ate. I understood very little Italian and so found time for reflection.

THE PHOTOGRAPH

This cold, hostile existence was causing curious results. It was my nature to live in an atmosphere of exalted hero worship. Finding nothing in the convent to feed these aspirations, I became morbid and turned for satisfaction to death itself.

Lying hidden on my chest against the coarse linen of the chemise nightgown was my most precious belonging. This was nothing less than the photograph of a dead sister. There she was, taken on her deathbed, bonnet and all, and extremely beautiful. How this lugubrious relic came into my possession I have now no idea, but I remember that in moments of stress or boredom out it would come to be gloated upon and loved.

THE RIVIERA

"You will continue to wear your convent clothes!" was my mother's greeting, as she waved away all efforts on my part to explain recent events. It mattered little to me what clothes I wore or even what sort of life awaited me

at the villa. Had I not seen the sun shining outside on the sea and on a beautiful terraced garden. My mother had recently purchased this property on the Riviera but its beauty left her unimpressed. Her country was not of this world and she wore the detached expression of one well aware of the fact. Yet on questions of the immediate division of earthly possessions she showed no lack of interest or decision: she had carefully arranged one half of the house for herself and the other half for my brother. My rooms were on the top floor. I was relieved at their remoteness.

Wandering through the house I felt unresponsive to the ugly fantasy that surrounded me. Like many literary people, my mother's choice was dependent on theories and her vision confused by poetical imaginings. The horrible aesthetics of those times afforded no help to the independently inclined. If she disapproved of wearing the clothes of a dead generation, why should she sit on its chairs and sofas? Besides, this sentimental clinging to the past could only unfit one for spiritual journeying toward the future; but above all, was not the main object of this villa to brighten up St. Amar's life?

The incongruity of my brother's bent form in an old black overcoat, shuffling his way over gaily flowered carpets, through suites of rooms scintillating with the highlights of silks and satins, can never be forgotten. Immersed in dark problems of his own, only the antagonism for some particularly aggressive object encountered on his way could bring him back to recognition

of his surroundings. His angry meeting with certain large jars that called attention to the embossed lifelike creatures, crawling over and clinging to their polished surfaces, was but one incident in his daily excursions through the house.

In the dining room he would stand before a prominent piece of oak furniture which was heavy with clusters of fat cupids lustily hauling from bracket to bracket a long oaken wreath. From this wreath fell huge gilded flowers, menacing the frail crockery displayed on the buffet below. To my mother these were pleasantly reminiscent of a shower of spirit flowers. To my brother the wreath was most suspicious; a nest of evil intentions.

I had been wrong in supposing that the sunny outer world could compensate for the mode of living in the villa. Unless disease is active and battles with health, it remains in its isolation a passive stronghold impervious to influence, making of limited space a universe of its own.

The broad marble steps, steeped in the sun, leading up to the house; the exotic trees surrounding it; the myriad flowers bathing it in their fragrance; all were powerless to change its inner darkness. The building was like a hot stone lying in a sunny garden which, when turned over, displays the damp, unpleasant insect life beneath. I fought hard to keep in contact with the sunny outer world, but my efforts were vain. By degrees I was drawn in by the very force of the infection about me.

Suddenly we left the Riviera. My dejection at the time was such that little of this departure remains in my memory. I followed, obeyed, and was surprised at nothing. Perhaps it was this half-alive state that decided my mother to send me away again.

A school in Switzerland was chosen. The mere thought of a noisy crowd of girls caused me agony. Indeed, what had I in common with them or they with me? Sooner or later they would find out this difference and rise up against me. But the dreaded day arrived, and this time, for some unknown reason, my mother provided me with a magnificent school outfit. Each dress, no matter how simple, was lined with rustling silk as was then the fashion. With two large trunks and an English teacher sent specially to fetch me, I arrived at Geneva to be installed at Mademoiselle Bertin's Private Finishing School for Young Ladies.

THE GREEK GIRL

This *pensionnat* was composed of girls of all nationalities. The pampered English, Russians, Americans, Germans, Greeks, Egyptians, though differing physically, were mentally very much alike. All had lived sheltered lives with their families; and all were preparing themselves for marriage and equally sheltered futures. The

one stranger among them was myself. I soon realized that only a continuous make-believe, with the help of my elegant wardrobe, would permit me to live through such dissimilarity. Pleasant smiles and a great rustling of silks sufficed to make me a popular member of this Tower of Babel Club where soon I was to become the center of rival passions.

One particularly ugly, red-haired Greek girl, who was always by my side in the closest proximity, stands out more prominently than the rest. This young person had a prodigious memory; she could rattle off by heart in alphabetical order the list of *personnages célèbres* in the Larousse dictionary. My memory, no doubt from want of sleep, was defective. Any demand on it met with a complete blank which hid not only the answer but often the question itself. This miraculous gift of memory in another, therefore, could only create on my part great admiration, if not love, and so allow the one-sided passion to go its own way.

This way led one day straight to my friend's room, although the rules forbade any such visits. My visit was discovered and I was called into Mademoiselle Bertin's presence. She asked me why I had gone to Helene's room. Now it was impossible to tell Mademoiselle why I had gone there, nor why I had so suddenly left. Even my conclusions concerning this affair could not be spoken about. Her surprise may be judged had I confided to her that, in my opinion, a miraculous memory was insufficient to inspire love; or that being loved without loving

was a wingless state, no substitute even for the agony caused by one's own ineffectual flappings.

Wisely, although my mind was filled with these thoughts, I remained silent. I gave, however, a firm and willing promise never to break the rules again or to enter Helene's room without permission. Helene, on her side, was angry and reserved her right to a Parthian shot.

THE RUSSIAN GIRL

As I had made no effort to replace my Greek friend I found ample time for peaceful reading and drawing in my own room. Unfortunately, a young Russian who had, as a child, lost her nose in an accident decided that she should be my next friend. Her admiration of my draftsmanship was such that she would amass all the sketches and caricatures which I drew on the margins of my copybooks during lesson times. But it was painful to look at her, for the relaxed muscles caused by her broken nose gave a simian expression to her otherwise girlish face. She never forgave my recoil and turned to my offended Greek friend for comfort. Soon I became aware that these two were inciting the whole school to rise up against me.

About this time there arrived at the school a Rumanian who was by way of being a musician. I now realize that her pretty face was weak and her music still weaker. But at the time she seemed to me very lovely, and when

she played the piano I would sit by her side enraptured. She was likewise attracted to me and proud of her ability to detach me from my other companions. This, however, was not difficult, for my hostility to herd life was such that I gladly took a stand against it.

Evident signs of a gathering storm left me indifferent; perhaps I was even glad to face what past events had taught me was bound to take place. Human nature being what it is, it would certainly have been very surprising if my mother's drastic orders depriving me of amusements enjoyed by my companions—theaters, small dances, even drawing lessons—were not to reflect upon me unfavorably.

One morning on entering the classroom I was quite ready to face Egyptians, English, Germans, and all the others, headed by a Greek and a Russian in open warfare. I had one friend, the Rumanian, that was sufficient; I never doubted her loyalty. With her by my side I could defy not only the school but the whole world too.

Alas! I was cruelly mistaken. My friend belonged to the herd; artfully they had approached her and finally drawn her away. This desertion caused me my first pangs of disillusioned love. The desire to evade the herd while at the mercy of one of its members was only one of many such paradoxical phases experienced during my troubled life.

Mademoiselle Bertin was dismayed at seeing how things were turning. Never had there been such a state of affairs in her school. "You must all meet and become

friends again," she said. Accordingly a meeting was arranged round the schoolroom table. I, the only stranger there, found myself face to face with the united hostility of many nations. My renegade friend was seated opposite me at the other end of the table. Caring little for the effect made by an impromptu action I got up and walked over to her. Placing my arm around her shoulder I began a speech in French wherein I sarcastically denounced "cette amie pour la vie."

Surprised, she said nothing, nor did anyone else. As my excited words allowed of no margin for reconciliation, it was in silence that I left the room to seek the isolation necessary to nurse my wounds. The make-believe was over. There was now plenty of time to draw sad, drooping figures under equally sad, drooping willow trees; or if the mood demanded, Death and the Devil rocking the cradle of doomed infants. I still possess the drawing of this last subject.

LOUISE

When at last these two uncomfortable years of school life came to an end, I found myself again with my mother. There was a certain eagerness in her greeting accounted for by the pleasure she invariably felt when my absence from "home"—as she euphemistically called our private and perambulating asylum—had proved an unpleasant experience.

"You must now stay in a French family to lose your Swiss accent," she said.

In reality, that I was now grown up came to her as a surprise, and she found difficulty in deciding how to dispose of me. With all her aloofness from life, she was not detached from certain feminine vanities. The desire to appear younger than her years was one of those.

By change, in the *Galignani* (the Paris *New York Herald* of the time) she found an advertisement that seemed to suit the occasion. At Neuilly a musical family offered the comforts of a French home to young ladies desirous of pursuing French and musical studies.

"You can take singing lessons," exclaimed my mother, without even knowing if I had a voice.

She took me to Neuilly herself and there, in one of the side streets we stopped at a small, dingy house which hid successfully behind it a still smaller and dingier yard. Monsieur et Madame Bidout, who greeted us in the stuffy sitting room, were old and unpleasant to look at; no less unpleasant was Toto, the fat brown dog who, jumping on Madame's lap, lay in its sagging center during the entire visit.

When the usual compliments had been exchanged and arrangements made to give me a sunless room overlooking the backyard—spoken of as *notre jardin*—Monsieur Bidout called out in a loud voice: "LOUISE!" ... and Louise entered the room.

"Voici ma fille," he said. "She is my accompanist. We shall both of us teach your daughter, Madame, to sing correctly the operatic airs."

I scarcely heard the pronouncement of this ambitious program, for my attention was riveted upon the newcomer. I think that my mother was also somewhat taken aback when she saw standing before her the diminutive figure of a hunchback. Two enormous gray eyes were looking at us in no friendly fashion. The sharp, painted face was crowned with a mop of frizzy hair falling low in a fringe over the forehead. There was no possible reason for this Toulouse-Lautrec face to inspire confidence. But my mother turned to Madame Bidout and said: "As I do not wish my daughter to go out alone I am pleased to think that Mademoiselle Louise will always accompany her on her promenades."

After this statement she got up and, leaving me in these strange surroundings, returned to her hotel.

Past experience had inured me to the unpleasant side of life. Other girls could enjoy the natural pleasures of their age provided by their families. My case was different, and whatever the circumstances, I could only be thankful to escape a more horrible life wedged in between my brother and my mother. I philosophically accepted this new predicament and, with a view to future freedom, studied hard to enable myself to gain a livelihood.

I did my best not to mind the many unsavory incidents which occurred daily in this particular family. I loved animals, but when Toto heaved his huge body on the table covered with a dirty tablecloth and there proceeded to poke his rheumy old nose into each place searching tidbits, it was nauseating to a degree. But Toto

was worshipped by Monsieur and Madame and allowed all liberties.

Then I was soon to find out that Monsieur had a violent temper which vented itself on such things as ants. A big species of these insects would follow an endless trail through the dining room. On seeing them, Monsieur Bidout, livid with rage, would get up and with the broad side of his dinner knife slash out and crush them in all directions. After this slaughter, wiping his knife on the napkin tied round his neck, he would continue his meal. This invariably turned my stomach, but not more so than the violent fits of choking and coughing which attacked him at mealtimes.

My bedroom was very cold in winter and during the summer, foul odors emanating from outside kept the window closed. I discovered that the dirty water and slops were carried down and dumped into a large hole in the "garden." By the side of this hole grew a fig tree which owed its unusually luscious fruit to the proximity of the cesspool. These figs duly appeared on the table but their honied succulence could make no appeal to me.

Notwithstanding my uncongenial surroundings, I firmly intended to concentrate my attention on my work. Already the intricacies of French syntax were less formidable, and the page's song in *Les Huguenots* could be warbled correctly, if not enthusiastically. All seemed to point to dreary but studious days and at first I scarcely noticed that the hunchback daughter of the house was exerting an influence over me.

She seemed removed by her deformity from ordinary human interests. I preferred not thinking about her. One day, however, looking up from under her fringe and fastening her gray eyes upon me, she asked if I would come to her room. It was gayer than mine, she said, and she passed the time there, sewing by the window, when she was not playing accompaniments for her father. I had no diversions whatever and as the stuffy bourgeois atmosphere did not permit of monastic aspiration, the day arrived when, in spite of my repugnance, I found myself knocking at Louise's door.

There remains vivid in my memory a picture of this misshapen little creature as she sat by the window almost lost in a huge armchair plying her needle with long clawlike fingers to the brightest of pink underwear. During this first visit the conversation was most usual and my hostess never lifted her eyes from her work. The next time, by way of something to say, I asked for whom she might be making the gay undergarments which were now being trimmed with tawdry yellow lace.

The reply was most unexpected: "For myself, *parbleu*! For whom else should it be? I wear them when with my lover."

I was lost in silent amazement, but she continued: "He refuses to leave his wife though he loves me; so now I am unfaithful ... Yet there was a time when, in order not to miss seeing him early in the morning as he passed my window, I would remain without bedclothes the whole night through so that the cold should keep me awake.

But now I have other interests; one day I shall tell you about them."

On returning to my room I was obsessed by the image of a wizened figure clad in pink-and-yellow chemise, amorously entwined in the arms of a lover. After this, discovering my ignorance, Louise was anxious to tell me everything about herself in particular and about all sex questions in general. She successfully converted the natural laws of life into shameful, though alluring, secrets. Her parents were too unevolved themselves to provide their offspring with higher aims and interests. They ignored the fact that the time would come when indiscriminate nature would demand the same toll from the hunchback as from any other of her creatures. So finding no outlet the crooked mind collected poisons more noxious than those of the open cesspool in the garden.

Until then my imagination had never dwelled on sex questions. St. Amar's obscene gibberings had made but little impression on me. I was unaware that my passionate attachments were related in any way to this new world of whispered revelations into which I was now plunging with moderate curiosity. From hidden corners of her wardrobe Louise would bring out pornographic books published in Belgium and obscene photographs printed in Holland.

"These," she would whisper, "must be read at leisure, preferably in bed, when no one is about."

Lewd visions and dialogues, not wholly comprehended, would obsess me during the whole day, even

when singing the page's song, which ever remains in my mind inextricably associated with this period of initiation.

A LOST ENTITY

When I try to look back on that particular period of my life, I am forced to conclude that one's past self can be almost a lost entity, a stranger one imagines can be brought back, understood, and followed. But how can one pretend to understand such a composite of contrary impulses? How can one write clearly about events that being illogical are without sequence and necessarily disconcerting? I can only be intrigued and alarmed when I try to bring into focus a certain youthful being that happens to have been myself.

In many ways I had the mentality of a ten-year-old schoolboy: frank and candid to a degree, but with a personal code that made small distinctions between what is generally called vice and virtue according to religions and fashions. These had no particular importance when dealing with my mother and brother. If I disliked certain conditions which existed at Neuilly, it was not that they offended my morals; rather it was that they hurt some aesthetic sensibility which, fortunately, I did possess. This sensibility was to be my solo ballast.

At that particular moment my plans for living the life of an artist were, of necessity, pushed aside by the im-

mediate urge for freedom. I see myself alone, pathetically inadequate, claiming of the world only the little I was capable of receiving. Yet, though it may be hard to detect in the following narrative, there already existed something that was bound to expand, an unconscious sincerity of effort that would bring about its own ultimate form of expression.

ROME

An affinity to the soil
of Rome, ruins, roots and hard
earth from which emerges a
sturdy Roman tree.

The artist is an active dreamer; his dreams are ever seeking their affinity to the outer world. To those who have no such tendencies he seems unreasonable: his moods strange, his decisions incomprehensible. It is quite evident that I belong to this artist order of human beings, for in the course of my life I have never done what is commonly called a wise thing. This is perhaps the reason why it was impossible for me to remain for any length of time preoccupied with the uncertainties of the future, and why the dreamer within me suddenly decided that the Odyssey of my artist's life should begin in Rome.

The long melancholy stretches of an Appian Way; the ruins whose death throes are prolonged by the fall

of each crumbling stone; the earth thickset with sharp, bone-like relics of its unburied past, bruising the pilgrim's feet; all these, in some unevolved and uncomfortable way, found their affinity within the structure of my mind.

Objectively, Rome meant only a name to me. One day, without preliminary plans, but with a third-class ticket, a valise, and very little money in my pocket, I found myself bound for that city.

I had never traveled third class before. The crowded compartment; the long, sleepless night; my thin self on the hard benches; all form part of an experience I shall never forget. My fatigue was such that long before the end of the journey I had lost all sense of direction and, what was far worse, my ticket.

Arriving late at night in Rome, I was surrounded by angry and vociferous railroad officials demanding my ticket. They all searched for it in vain. Finally they allowed me to enter a hotel omnibus which was, as by some miracle, still waiting for me at the station. Already seated inside was an angry English lady. In my excitement I explained to her in French that I had lost my ticket. She snapped back that I ought to have known better.

On arriving at the hotel the manager, finding that his visitor was a young girl traveling alone, began making advances. He was so persistent that it was only by menacing him with a small mother-of-pearl-handled pistol, which had been given to me by my brother's doctor, that I got him to leave the room. When he retreated I found

that there was no key to the door; for the rest of the night I sat up in order to watch it.

Finally the morning came bringing reassurance and I decided to undress and take a much needed rest. On opening my valise, strange articles of toilet fell out. There had been an exchange of bags when the omnibus was unloaded. Unable to stand more I flung myself fully dressed on the bed and fell asleep. A few hours later I was wakened by the *cameriera* who came to bring me back not only my valise but also the lost ticket.

I then decided to leave the hotel at once and seek out a *pension*. As I passed through the corridor, the English lady came up to me and apologized for having been so unsympathetic the night before. She had taken me for a French girl, but having found out her mistake she wanted to offer any help I might need. I thanked her, but I knew that in the future there would be no asking for help whatever happened—it was not my way.

I stayed at the pension until I had chosen—and not too judiciously—a studio in the Via Sistina. It was on the ground floor at the very end of a dark corridor which for no apparent reason smelled of roses. When I agreed to take the place, I was unaware that the passage was left unlighted at night; the long walk through its vault-like dampness, guided only by the flicker of small wax taper, subsequently proved no pleasant experience.

The studio itself was the usual bare room; and opening into it was a kind of alcove where wedged in between high, windowless walls, there was a large bed that looked

dirty. I always used to hesitate before getting into it, and would then curl myself up in order to escape as much as possible the disagreeable surroundings.

On the day I chose the studio I visited the manager in his office. He was young and most obliging, but as I was about to leave the room he got up and, to my surprise, began expressing in passionate terms the pleasure he felt at my having chosen the studio on the ground floor. His own rooms, he explained, gave onto the same garden, and he could easily manage to climb into my room at night to visit me.

I left the office without showing any signs of having understood him but later, although the studio was often hot and stuffy, I carefully kept the window closed at night.

Judging Italian men silly I carefully avoided making friends with them. Yet I was entirely free from prejudice and had none of the hypocrisy of the Anglo-Saxons who generally show strong antagonism to all sins other than their own. But it was one thing to be unprejudiced and another to be the object of attention of a seemingly sex-starved population. The importunate guide or beggar was a pleasant person indeed compared to the hungry male who sidled up to one on the streets, and with steel-like fingers tried to pinch what ought to have been the fat part of the body but which was, in my case, as thin as the rest. But fat or thin, one was young and that was sufficient. I soon learned that a pleasant walk alone was impossible. The male was always present, following, or waiting, if one happened to stand still an instant.

All this, however, is but a sidelight on what was merely disagreeable. The real struggles of my artist's life were yet to come.

LA FLORA

Not far from my studio was a small restaurant which conveniently allowed its customers to pay their bills, with a discount, at the end of each week. Known as La Flora, this place was frequented by students, writers, and such others as made up the foreign element in Rome. There I lost no time in getting information about art schools in general. I was told that there was only one free of charge—La Scuola Nazionale. All I had to do was to send in a drawing as test of my ability. This I did and it was accepted. Shortly afterward I found myself the only woman attending a class filled with men very much like the ones that followed me in the streets. But there, at least, they were under some sort of control: an elderly man, seated at his desk near the entrance, kept order.

I hated this school; yet I walked to it twice a day in order to draw from the nude. Later on I also joined the night sketch class at the Circolo Artistico, where there were other women students.

In such wise I worked three times a day and even at odd moments in my studio. I have sketchbooks filled with views of the garden, my face seen in the mirror, and my left hand in all possible foreshortenings.

But this even course of hard work was interrupted.

When in due time my mother's letter reached me I found to my dismay on opening it that, though it contained the usual "Here enclosed is the sum of three hundred francs . . . ," the three precious notes were missing. The envelope had been tampered with and the money stolen. My gentle request that such letters be registered had remained unheeded.

There I was then, faced with the predicament of meeting the needs of a whole month with only a few coins jingling lonely-like in my pocket. I wrote back at once telling of my loss but I expected no reply and received none. Fortunately my strength of will proved equal to the test. Not for one instant did I admit of either defeat or the possibility of seeking aid.

For the time being, the Flora was to see me no more. A glass of milk and a bun from the *latteria* was all I could expect as a meal. Perhaps these buns, containing the seeds of pinecones called *pignoli*, were more sustaining than ordinary buns. At any rate I survived on them for a long time. Toward the end of the month when even these became scarce I remained in bed and waited, with a very empty stomach, until my next allowance came. It is hard to surmise what might have happened had the letter been late.

On returning to the Flora I was very relieved to find that no one knew the reason of my absence. But it had been remarked and especially by a young English painter whose place at table was opposite mine. He was blond, wore glasses, and always ordered boiled eggs and po-

tatoes instead of the usual Italian fare. As a follower of Burne-Jones he thought a great deal about the soul and had told me that only the great Master himself could give to my face the soulful expression it lacked.

The day I arrived at the restaurant in a half-starved condition this Englishman stared admiringly at me and exclaimed that never had he seen the soul so manifest on any face before. I did not tell him that in my opinion an exclusive diet of *pignoli* buns had much to do with it. But from that moment we became friends and later I enjoyed many unmolested walks in his company. Once, when we went to the Colosseum, he actually fell into a lion's den, for he was very nearsighted. It was at the end of the day and his sudden disappearance coincided with the sound of a voice rising from a dark pit. He had lost his glasses in the fall, was helpless, and would I call the *custode*, I heard him shout. When finally extricated, he was found unhurt but still worried about his glasses.

This young man was engaged to be married to an English girl, but before leaving Rome he changed his mind and asked me to marry him. It is doubtful whether at that time I was able to analyze my feelings about such a conventional affair as marriage.

I was perplexed and certainly amused. It was clear, however, that I could not speak to my unsophisticated friend about such things as: the determination to remain outside the circle of conventions; the disdain felt for the protected ones within that circle. Did I not consider myself as one of *les lapidés*?

There was a periodical published in Paris which bore that very title. It argued in favor of those who in life were attached and stoned by the Philistines. The name of Jesus Christ headed the list and was followed by many others famous in the history of the world. It was an honor to belong to such an army.

Unless pampered into submission, youth is naturally rebellious. My rebellion took the form of hating the conventional. Besides, I had my own experiences to go by. Who within the despised circle had ever come forward to help me? The rich relations who now held aloof from the unavoidable break with my mother had never raised a voice on my behalf. I had always stood alone and would proudly continue to do so.

In the end it was with a feeling of relief that I saw my friend off. Thank goodness, I said to myself, there would be no more ridiculous talks about marriage; also, no more walks to take me away from my work.

RONALD WALTERS

In prosperous moments it was my habit on the way back from the *scuola* to stop at the Café Greco and, without sitting down, eat a cake or a sandwich which took the place of dinner. The Café Greco was, and probably still is, the meeting place of the intellectual foreigners in Rome. I remember it as being on a side street and very quiet.

One day I stopped there as usual and was about to

eat a cream cake when I caught the amused glances of a young man seated at a table. I recognized him. Once, passing by, he greeted my English friend who thereupon introduced him to me as Ronald Walters. He now came up to me, shook hands, and began at once in an Oxford accent to declaim against cream puffs. Never would I eat one again if I knew in what a "beastly awful" way they were made.

I scarcely listened to what he said for my attention was entirely occupied by the personality of the young man standing before me. In reality he was an intellectual Oxford student who had, like many others, passed successfully through the medieval surroundings of an English college to emerge with the mentality of a Greek pagan.

But what I saw at the time was an attractive combination of sophistication and extreme youth. Even the features followed this double tendency, for though the marked eyebrows met low, they failed to throw the slightest shadow on the clear eyes beneath; and the boy's smiling mouth claimed no relationship with the cynical lines that encircled it.

There is no doubt that we are mutually attracted to each other, for when he asked to accompany me to my studio I consented, and on the way there we planned a walk for the following day. That particular walk, however, never took place, for when I arrived at the café, after my work, who should I find there to my surprise but my English artist friend who had supposedly left Rome, as I thought, for good.

He had come back to see me. About this unexpected meeting I can remember very little except that without rhyme or reason we all three decided to go that very night to Assisi to see the Giottos. We traveled third class, each carrying as luggage a piece of soap and a toothbrush. In my sketchbook there is a Burne-Jones-like drawing showing me asleep on the bench with my head resting on the Oxford friend's lap. This sketchbook also contains many of my own drawings of the churches and towers of Assisi.

I have no idea what effect the Giottos made upon me. All I can remember is that when in their presence, evidently feeling conscience-stricken, I exclaimed aloud that I was wasting my time and wanted to return at once to my work. This my companions ascribed to an almost presumptuous faith in my own abilities.

At any rate we returned to Rome and shortly afterward my painter friend departed once more … this time for good. As he was leaving he turned to me and significantly quoted a verse wherein the poet spoke regretfully of a flower that turns to seed. Ronald protested. I thought nothing about it one way or the other.

Ronald, on leaving Oxford, had visited Oscar Wilde and reflected some of the brilliancy of that remarkable personality. His paradoxes came straight from the master but they were new to me, so I admired the pupil. He brought, however, to my receptivity a world enriched by its many sensuous suspects of beauty; and I …

… marked him trace
Under the common thing the hidden grace, …

Till mean things put on beauty like a dress
And all the world was an enchanted place.

Though I willingly adopted this new mode of thought
it never really touched an inner depth of Romanticism.
And once, when I showed Ronald a small edition of
Childe Harold's Pilgrimage which never left my pocket,
he laughed and called it old-fashioned. He advised me
to read John Addington Symonds and, above all, Walter
Pater. I had not sufficient knowledge to fully understand
Pater, though in *Marius the Epicurean* I sensed intuitively
the wonder of a prose that could lift one to a Greek world
of polished shadows.

But I was not a pagan. The mirage could divert but
never appease the melancholy abstractions of a black-
cloaked traveler.

Ronald was studying archaeology and he confided to
me once that before meeting me he had been very much
in love with the marble head of a beautiful Greek boy
found in the excavations. This seemed natural enough,
and I in turn confided to him that when in the convent
I had loved the photograph of a dead nun.

We went about together and there was not a single
ruin, gallery, or monument in Rome that we did not visit.
We also walked a great deal outside Rome, and one day
near the river we saw a group of Italian lads with fishing
rods approaching us. Ronald became perturbed and red
in the face. He nodded to them as they passed and then
told me that they were friends of his and knew how very
much he disliked girls.

"Of course," he added, "they will see that you are not like other girls. Your face is even more frank and open than any boy's."

I doubt whether I thought this a compliment, for being unable to afford models I had filled my sketchbooks with long, mournful faces supposed to be mine. My arched eyebrows were drawn straight, and the general expression had a sarcastic turn which I am sure was not the case. But this was evidently the way I wanted to look, for a curved and even smiling profile was purposely ignored.

LA SCUOLA

My attendance at the scuola, as I have already mentioned, was an ordeal. As ill luck would have it, at the very moment of deepest dejection, I found myself involved in a very unpleasant affair. The curiosity aroused by my presence had never abated and the antagonism I felt against that particular group of young men was intense. On the other hand, the advantage of being able to work from the nude free of charge could not be overlooked; besides, there was no tuition, or rather it could be easily avoided, and this coincided with my views on the merits of studying without a master. But my barely tenable position in the classroom was to be further assailed, and in the following manner.

One morning when I was about to resume my seat I found on the high stool a particularly disgusting

picture card. I knew it was my neighbor who had put it there. He was older than the other students, had a beard, and wore eyeglasses. In order to stare at me he neglected his work, and whenever I changed my place, he also managed to change his. Lost in my work I could forget this annoying person, but his object was to attract my attention. Without even looking in his direction I swept the offensive card off the seat.

The following morning just such another card was on the stool. Again I threw it on the floor. But the third morning there was an open book with certain passages underlined for my benefit. My neighbor, seated in front of me, had turned round and was whispering: "Signorina! Signorina!"

This was too much. Seizing the book I leaned forward and smacked his face with it. His glasses fell off; he became crimson. I stood up fully expecting to be hit back. All the other students stood up too. Then, as there was no retaliation, I profited by a moment of surprised silence to express my indignation as best I could, and seizing my drawing I walked out of the room, leaving pandemonium reigning on the other side of the door.

Somewhat agitated I reached the Flora but refrained from speaking about the incident. Later the news leaked out. An American student exclaimed that it was all my own fault as I gave no one the right to protect me. I did not quite understand and thought it a very peculiar way of putting the matter. Protect me! And who should I ever ask to protect me?

This unpleasant affair, however, did not end there. A few days afterward a young man from the scuola called at the Flora to see me. He was sent as emissary by a group of students to express their regret at what had happened and to request me to return. I had been, in fact, delighted to have some justification for leaving the school, but the emissary was so persistent that I finally promised to return.

The next morning all was quiet in the classroom. The young men seemed anxious to show how well behaved they could be. When I dropped my pencil there sprang forward not one but a dozen students to pick it up. I regretted my former attitude, but as subsequent events proved, it had not been entirely unfair.

Once again the young emissary came to the Flora but this time it was to request me not to return to the scuola. He explained that all the Sicilians were siding with my bearded neighbor who had declared publicly: "No Sicilian accepts a slap from a woman." I was right, then: there had been a possibility of retaliation.

That very morning I had noticed the peculiar attitude of some of the students. They were standing in groups in the street as if plotting together. As I passed them, they turned suddenly and faced me in silence. "They are planning some vengeance," said my interlocutor, and then irrelevantly he began talking about himself. His father was a prosperous tailor, his home in Brescia. He would like to have a wife *con molto spirito* like the signorina. What did she think about it? I answered that I was

already affianced, knowing this was the proper thing to say. He expressed his regret and before leaving repeated his warning against my returning to the scuola.

No further warning was needed, for I had already planned to pass the time more agreeably by drawing from the statues in the museums. After this episode I was more apprehensive than ever when walking along the dark corridor that led to my studio. The Sicilian was lurking somewhere about, perhaps ... If I returned late from the sketch class I would try to induce certain Anglo-Saxon classmates to accompany me to my door. They all did so in turn until they found that my ulterior motives were not theirs.

FRIENDS

During my stay in Rome several people suddenly entered my life and as suddenly left it. They were, for instance, the Roman painter and his bereaved wife.

Before leaving Paris, an artist friend gave me a letter of introduction to a prosperous Roman painter. Incidentally it was this same friend who gave me a huge old watch and key of no value which had belonged to his father, he said. I accepted this gift sensing that it might be useful, and indeed, for five years the pocket of my jacket sagged with the weight of the heavy timepiece.

I posted the letter of introduction and a reply came back inviting me to call and lunch with the painter and

his wife. I found them nice, bourgeois people, and the lunch a welcome change from the usual fare at the Flora. During the meal the wife suddenly burst out crying. She got up and coming over to me began kissing me while her tears ran down my face. This embarrassing behavior was caused by my resemblance to a young daughter who had recently died.

Although I lunched several times with these people, the lady never once refrained from crying. I soon found myself torn between two desires: one, to have a good meal, the other, to escape these scenes. All came to a head when the stricken parent proposed that I should go and live with her as her daughter. It seemed to me an absurd proposition. She had mistaken me for the usual young girl, whereas my mental outlook was that of one who had always had to struggle. Moreover, I did not admire the painter's work; he specialized in designs for frescoes—endless arches, columns, and perspectives with groups of draped figures, inspired by the old masters.

Clearly it was time for me to give up the luncheons. On receiving the next invitation I sent word back that as I was not feeling well I would stay in bed for the day. Then, as usual, I went out to work. When I returned in the evening I found a note under the door. The painter and his wife had both come to see me. What explanation could I offer? There was none, unwilling as I was to meet even halfway their well-meant intentions.

I cannot remember how it came about but one afternoon found me in my studio awaiting the visit of a lady

who knew, or knew of, my mother. There was a prospect of her buying a drawing, but why that should have seemed possible remains a mystery.

She arrived and proved to be just such another Anglo-Saxon as could be seen drinking tea in the "English Tea Room." Ronald had told me that all these women were stupid and mischief-making. This particular one was stout and short of breath. She complained of the long dark corridor and after sitting down on a rickety chair began examining the room.

"And to think that your mother lives at the Château Grimaldi!" she exclaimed.

Suddenly I saw her eyes dilate with horror. She had caught sight of my drawings tacked to the wall.

"Is it possible that you draw *these*?"

These were charcoal sketches of completely nude models which I had done at the scuola, where loincloths were not worn. I was so shocked at her attitude that I remained silent.

When she recovered from her astonishment she asked to be shown some nice watercolors of pretty boys and girls in Roman costumes, like the ones in the shop windows. I knew very well that I had nothing of that sort to show her, yet I drew forward a large cardboard case and opened it to the astonished gaze of my visitor. The case contained drawings like those on the walls: nude men, women, and children seen from all angles—mere notes of masses and proportions.

An exclamation made me aware that my visitor was

looking at an unusually proportioned little boy. True to my views on the exact rendering of a model, I had noted him as he was. After one glance the lady shut the case and rose to go. In silence I conducted her to the door. There, another shock awaited her.

Pointing to the name of a former occupant painted on the door which I had never thought worthwhile effacing, she exclaimed: "What! You are also living with a man?"

I tried to explain, but she was grimly hopeful for the worst, determined not to be deprived of her titbit of gossip for the Tea Room. This woman, and many like her, proves that Virtue has her playful moods and would have us blush at the unconscious impropriety of her would-be followers.

IMPRESSIONS

I have written so little about my first impressions on seeing Rome that it has set me wondering what they really were. It is a pity that much experience is needed before the mind can put into thoughts what has come to it as impressions. Yet if one dwells on any particular period of one's life, beneath the strata of the thinking mind, these early emotional pressures can be evoked, though they lose on taking form. By them the real tendencies of a nature are revealed; and they stand quite apart from memory-cataloguing.

Obsessed by my work, restricted by intermittent want, limited and molested because of being a girl, I was barely able to survive. Yet from that first contact with Rome there came a feeling of melancholy—pure melancholy allied to beauty. But only when wandering alone—and I have mentioned how hard it was—could I lose myself in this abstraction. When accompanied, sight-seeing became merely memory-cataloguing.

To the artist, only what the Ego has awakened can be worth the keeping.

THE SPANIARD

Summer had begun and foreigners were leaving Rome in order to escape the fever which in those days was prevalent during the hot weather. I also decided to go away but my decision was taken more on account of certain troubles brewing at the Circolo and brought on by my own indiscretion than from any fear of fever.

These troubles concerned a certain Spaniard. He had been educated in England and deported himself with such dignity that he was never seen to smile. When I met him I concluded that education could do much to change the nature of a Latin.

This clever artist showed discreet interest in my work and on arriving at the Circolo I would sometimes find "Good" written on the margin of my drawings. So when he asked to paint my portrait and promised to give it

to me, I consented to pose during odd moments at his studio.

For a time the sittings passed off agreeably enough. The painting showed me in a white sailor hat, a veil, and a white-and-red checked tie, and though in my opinion it was not what a portrait should be, the work was undoubtedly clever. During the poses I talked as naturally as I would to an Anglo-Saxon. I had not the slightest idea how to flirt and this had already been remarked upon. Nevertheless the moment came when the Spaniard argued that my willingness to pose could only mean compliance in other ways. I disagreed and refused to return to the studio.

At the Circolo, certain dark glances sent in my direction were sufficient to cause apprehension. And when I heard that there were threats to kill me with a knife, I was forced to admit to myself that education did not necessarily change one's nature. Things therefore having come to this pass, it was undoubtedly the moment for me to leave Rome.

Someone had spoken to me of Capri; it was there that I decided to go.

CAPRI

At the end of the last century Capri was still unique in character. Though only two hours away by boat from Naples, it might well have been an island in the archi-

pelago of faraway Greece, so undisturbed it was. Artists who loved color sought its beauty; intellectuals who were weary, an ideal retreat. To those who felt strange currents beneath the soil stirring them into fever, Capri was a pagan island, and Vesuvius its burning God. The peasants were beautiful and simple children who liked the foreigner because his fever brought them gold.

The island was filled with music; rhythmic calls and responses in the vineyards; sounds of flutes from the hillsides, and at Christmastime shepherds clad in sheepskins came to play their bagpipes at the Virgin's shrines. The first time I heard these pipes I was painting, seated on the rocks. The sounds that came floating toward me from some distant shrine did not evoke the Virgin but drew me back to a pagan world whose music had not as yet died. I dropped my brush and could not work again. In Capri, time was not one with the present moment, and efforts were but tributes paid to other days.

The other, the melancholy self, will sleep as long as I live here. These were my thoughts as I drove up the dusty road that runs between old walls and powdered oleander trees, or along the vineyards that looped with green the sea and Vesuvius paled in distant blue.

But the spirit of an ancient place works in unexpected ways. I was unaware how it should work in me.

My choice of a pension was ruled by finding one with the lowest summer rates—five lire a day. It was comfortable and my room gave onto a palm-shaded garden. But I did not respond to my surroundings nor could I overcome a bad state of nerves. At night I would be wakened by the cries of strange birds flying over the island. Rushing to the window my alarm would increase on finding all things silent in the transparent darkness of a southern sky. No one else seemed to have heard these birds, so I spoke no more about them.

In the dining room, as I faced the other boarders, there would come over me the same nervousness felt as a child at St. Catherine's. During meals, in order to hide this state, I would sit in silence. This attitude intrigued my neighbors who were, for the most part, boisterous tourists. What with my melancholy air and clothes unsuited for the season it was evident that I did not belong to their tourist world.

As time went on my state of depression increased and even deprived me of all desire to live. When I stood on the cliff beneath the Castello and gazed down on the sea far below I would want to throw myself into it. Work seemed to no longer have any meaning; all efforts to paint the peasants, who posed willingly for a few *centesimi*, proved a failure. I would wander about, plant my easel in some isolated pathway, and then sit before it for hours doing nothing.

How could I know that Capri was molding me to her ancient form. Such were then her ways with those who lingered on her shores. She took away to give instead what she herself contained. At first it caused resistance and despair, and then it brought freedom to find the latent pagan within oneself, or simply to live without ambition, breathing the soothing air.

THE OLD CHAPEL

Before many weeks had passed I again felt anxious about my allowance. It was late. Rather than face a bill that could not be paid I decided to take a studio where it would be possible to retire during the hard times that were perhaps in store for me.

My decision to leave the pension happened to coincide with the arrival of an American woman who, unlike the tourists, had come to live in Capri solely to have a good time. She was big and blond, and had left behind a husband in some damp and gloomy house in London. She kept shouting in so loud a Yankee voice to the little daughter she had brought with her that I feared the tiny ears would soon grow deaf to more subtle tones, let alone a whisper. But beneath her boisterous nature was a fund of kindness which led to our becoming friends.

She understood, somehow, that I was passing through a crisis and her breezy, optimistic nature did me good. She knew the foreigners living on the island

and it was through her that I met them. Together we searched for a studio and finally found one that had been a chapel once and still retained a high, Gothic window. A small adjoining room which was an old Italian combined lavatory and kitchen made us laugh. The rent was only twenty lire a month because the place was in the slums—if such a name could possibly be given to any part of Capri. Who else on the island, from his terrace, could have had a better view than I of the sea and the Castello, and were there not orange groves and vineyards at my very door?

The arch that led into the courtyard had been made by someone roughly pulling out the stones of a wall. There were clothes hanging up to dry; and my near neighbor was the island's oldest beggar who sat and sucked his pipe beneath a fig tree. I liked that happy beggar and always gave him *centesimi*. Later on when my change of fortune came, it was he I thought of first. Waving his bundle of banknotes, he danced about the courtyard with cramped-up legs, shouting, "Viva la Signorina Romana!"

The only furniture in the studio was a small divan mattress and a chair; but there were windowsills and niches in the walls to take the place of tables. The brick floor was painted red and the room was lofty. House lizards ran along the ceiling; the baby ones, whose legs were still too weak to cling, would fall upon my head. I made the acquaintance there of all the queer insects of the island; fat worms with padded feet that tried to crawl up the walls but whose weight pulled them down with a

soft thud to the floor; and spiders the size of saucers that I had to kill and then wash away their mangled bodies.

But the place was Paradise compared to facing the pension boarders. To complete the furnishing of it I coveted a tall and rickety desk seen on sale somewhere—a remnant of an old-fashioned office. The price, however, was thirty lire. My American friend also thought my studio was too empty and contrived, without my knowing it, to bring me the means of buying not only the desk but a table and another chair. She was who introduced me to Mr. Thomas Burr, an American author. He ordered his portrait from me for which he was to pay fifty lire.

MY FIRST PORTRAIT

Mr. Burr's face was all beard and hair and during the sittings he became sentimental, which added to the difficulties of painting the portrait. Though disappointed in me, he was, in the end, pleased with his hairy image which he paid for and took away. Then he ordered another, bigger one. This time he wanted to sit writing by the open window with the Castello seen in the distance and a pot of flowers on the windowsill. He wore knee breeches and his fat legs were crossed in clumsy fashion under the small table.

As the painting progressed he became more and more displeased with my resistance. Finally, disillusioned, he left the island without taking leave, and what

was worse, without purchasing the almost finished portrait. Later I heard that it was so rough when he left the rowboat to board the steamer that all his baggage, including the first small portrait, fell into the sea.

For a long time I had to look at the large, ugly picture as it stood on an easel in my studio. Somehow I managed to finish it and, a year later, when I went to Paris, I rolled up the canvas and took it with me. I knew Mr. Burr had a flat in Paris, and in a moment of need I decided to visit him. He seemed very glad to see me until his eyes caught sight of the rolled-up portrait, then his whole mood changed. He became angry and told me frankly that he had no intention of taking it unless I became his mistress. When he tried to kiss me and I resisted, he crushed me against the wall. His manners were so rough that my only thought was to get outside the door. This I managed to do; but the portrait was left behind. I thought, of course, that he would send it back to me. Yet though I wrote to him I never heard about it again.

That, then, was my first experience as a portrait painter. However, I *was* able to buy the coveted desk and arrange upon it my library of ten books. Over the lower part of it hung a curtain hiding an iron washstand, and standing before it was a high stool. This stool had to be climbed but once seated on the top I would remain contented, leaning over the desk holding a pen in my hand as though about to write.

But more important than the purchase of the desk was the reproduction of a small portrait that appeared

in the *New York Herald* with a paragraph of news from Capri: "Mr. Thomas Burr, the eminent author, now visiting the Island of Capri, has had his portrait painted by Miss R. G."

Later on I learned that my mother had also read this notice.

UNCLE CHARLEY

The other people living on the island with whom I had become acquainted were mostly men and Anglo-Saxons, and as such they made a pleasant show of friendship for a time, at least. This atmosphere of appreciation caused me to become more sociable, but being very independent I never once spoke to them of my own troubles. Not one of them knew that a luncheon or a tea was sometimes accepted because it was the only meal I could expect to have that day ...

Mr. Charles Coleman was the oldest of these friends. He was an American artist who painted pale pink-and-blue pictures of Vesuvius; he also harbored a secret sorrow about Rosine, his peasant model whom he had been unable to marry because his wife was shut up in an asylum. One of his friends, however, married her and took her off to Scotland where they had eight children.

Charles Coleman was distinctive in that his own decorative self—tall and slender with white hair massed like sculpture—seemed to induce all things about him

to become equally decorative. His very garden looked artificial, so *stylisées* were the plants that grew there. No fig tree on the island spread branches so curiously curved and twisted as his own. Everybody marveled at the oleander tree that sprang gracefully from the center of his house filling the small court built around it with red flowers that pressed into the doors and windows. No such other plant life could be seen on the island of Capri.

When I first met Mr. Coleman he was in love with my blond American friend. With me he could never quite decide what role to take: aspirant or parent. I thought him egoistical and vain, and judging from my experience these were certainly the attributes of a parent. He could pass as an uncle, perhaps, and it was to this role that I limited him.

He offered me the hospitality of his house if ever I should need it, but it was very far from my intentions ever to accept the offer. One evening, however, on returning to my studio, I found it filled with flying ants. As my divan was covered with these insects I wondered where I could pass the night. It was then that I thought of Uncle Charley's guest room.

I went to his house and his old servant told me that *il signore* would be out late that night but she was willing to install me in the guest room without saying I was there. I slept undisturbed and got up early, hoping to slip quietly away. But on the staircase I met my host.

"And why this early visit?" he asked with surprise.

Laughing, I thanked him for the hospitality of the night before and added that I was going back to my studio, which I hoped was now free of flying ants. I left him there, pulling at his beard, as he muttered something about being "very pleased indeed!"

MY SECOND PORTRAIT

Facing the Tragara walk was the home of an English explorer, Mr. James Whipple. He had retired to the island on the death of his wife and in the sitting room of his villa was a large photograph of her in her wedding gown, a wreath of flowers about her head. We became friends and though his friendship for me lasted to the end it had one eclipse.

In spite of his sadness Mr. Whipple could not prevent the workings of an ingenious mind. He was always planning diversions somewhat too Anglo-Saxon for Capri—roller-skating on his spacious terrace, for instance, but I cannot recollect anyone availing himself of this pleasure.

He it was, also, who inspired certain ceremonies in the cave under the Tragara, which in Roman times was used for the worship of the sun god Mithras. When we were all friendly we met there: Mr. Whipple, Mr. Freer, Mr. Charles Coleman, and others whose names I have now forgotten. We were crowned with leaves and dressed in the kimonos which Mr. Freer had brought back from the East. Walking in procession we chanted verses from *The*

Rubáiyát of Omar Khayyam, which had been set to music by John Brooks, the poet and musician of the island. Then standing on a rock altar I sang: "Yon rising moon that looks for us again."

After which, in propitiation doubtless, for singing of the moon when we were worshipping the sun, Mr. Jerome pronounced a ponderous discourse on Mithras which nearly sent us all to sleep. Finally, to make the ceremony more lively, the explorer sat on the ground and performed miracles. In one of these, I remember, he waved a broken leg in the air and then proudly stood up to show that it had joined his body again.

The Englishman proved a good friend. He bought one of my paintings: a Capri child holding a bunch of berries. The two hundred lire he paid for it helped me to be one month in advance of my irregular allowance. Then, like Mr. Burr, he too ordered a full-length portrait. He decided to be painted in a smart khaki outfit with a topee and leather boots, seated on a campstool jauntily holding a cane across his knees.

I have already stated how very hard it was to work in Capri and the mere thought of this ambitious portrait exhausted me. But the huge sum of two thousand lire was to be paid for it—enough to make me independent for a whole year. I gathered up all my strength and courage in order to face the ordeal.

Mr. Whipple was then living in a villa at Ana-Capri: he had asthma and needed the higher air. So after procuring paints and canvas I took a cab up to a pension where

I intended staying while painting the portrait. Leaving my valise there I proceed to the villa. I knew, of course, that Mr. Whipple was in love with me, but I tried to ignore the fact, hoping that it had nothing to do with his ordering the portrait.

Finally, all was arranged and I seated before my easel, when what was to be expected happened. My sitter jumped up from his campstool and threw himself before me in all his khaki splendor, pouring out what had been on his mind for months. I suppose I should have been patient and made light of it all, but being solely intent on my work, I became angry and left the room. More, I went to the pension for my valise and walked with it all the way back to Capri. And so ended for a time our friendship.

But Mr. Whipple went round to his friends on the island and was so doleful about the way I had received what he termed his "serious intentions" that many of them sided with him against me. Uncle Charley, of course, was among these and when he gave an evening party he invited my admirer but not me. Resting quietly in bed, listening to the music that came faintly over from his garden, I felt very relieved indeed that events had made it impossible for me to paint the khaki portrait.

Life in Capri, however, failed to harmonize with the artist's side of my nature. And indeed, what had my predilection for the sad and gray to do with the sharp Capri sunlight and blue shadows? Yet it was a small painting of a sunny pergola with green vines and purple grapes that I sold twice over. One day Mr. Whipple brought to

my studio a friend of his who chose this picture to take back to his wife in England. Then Mr. Charles Freer, who was visiting the island, also bought it. They each sent me two hundred lire though there was only one painting of its kind for sale. I was in a dilemma but eventually the picture went to Mr. Whipple's friend who was leaving. I then asked Mr. Freer if I might paint him another, later. He agreed with a smile, whose meaning I did not understand at the moment.

These two sums received enabled me to further my plans to go to Paris and work at Colarossi's. Eventually I found myself again uncomfortably seated in a third-class compartment on the long trip back to Paris. I arrived late at night, and having neglected to decide upon a pension beforehand, I had to ask the cabman to decide for me. He stopped before a small hotel not far from the Académie Colarossi.

The following day I took a room that was cheaper in the rue Vaugirard and then began attending classes three times a day. The payment of these was, however, none too easy, so I retrenched on my food. Perhaps, nowadays, the restaurants that cater for the students give good fare; then it was very poor indeed and I was always hungry. To make matters worse, winter was approaching and I had no warm clothes to wear. It was at that time that I made the unsuccessful attempt to get Mr. Burr to buy his portrait.

But someone else did come to my rescue. While working at Colarossi I made friends with a young Russian girl

who was studying art as a pastime. She took me to her home to meet her parents, who made a point of inviting me to meals. When they noticed that my clothes were insufficient for the season they forced me to accept a black astrakhan coat.

Their kindness, however, did not prevent my falling ill with pneumonia, but it was their own doctor and my friend herself who took care of me. She found it hard to believe that a parent could be actually unfriendly and so insisted on writing to my mother about my illness and need of money. Her astonishment was unbounded when she received no reply.

I was so run-down and threatened with lung trouble that the doctor advised me to go to Switzerland. This seemed impossible to accomplish until I remembered the small village of Gruyères not far from Geneva where Mademoiselle Bertin used to take her pensionnaires for the summer. It was cheap and in the early spring would be still cheaper. I finally went there and remained during the spring and summer, working most of the time out of doors.

MR. FREER

The early autumn found me back again in Paris. There I was surprised to receive a note from Mr. Freer. He was passing through and asked me to dine with him. I accepted and afterward he took me to a variety show where

the chief interest seemed to be the gaily dressed ladies strolling about the *promenoir* ogling the men. This certainly interested Mr. Freer immensely. It was evident that he wanted to play the role of initiator for he would glance at me to see how I was taking it. There were no signs, perhaps, of the antagonism I was feeling for what had come so near to me in the past; but as I was bored, too, that was certainly the expression he saw on my face.

Perplexed but not discouraged, after the show Mr. Freer invited me to leave with him for England, where, he said, a sentimental trip up the Thames would be very much to his liking. Afterward we could go to America. The meaning of the smile that had accompanied the agreement over my picture was now clear. Besides, I had since found out that Mr. Freer was a great collector of Japanese screens and Whistler etchings. What had these to do with my potboiler—the purple, green, and yellow pergola? I asked to be driven back to my room.

I never saw Mr. Freer again, but later on, my financial situation having changed, I sent him back the two hundred lire he had given me for the picture I had promised to paint for him. In his reply he declared that I was more deserving of a fortune than anyone else he knew.

RETURN TO CAPRI

On returning to Capri I found S. D., one of my island friends, in a hopeless situation. He was contemplating

suicide and confessed to me that his capital, on which he had been living for many years, was now exhausted. He had no idea what to do—or rather what to do so as to be able to do nothing. He had friends who were rich and successful, and I felt sure they would come forward to help him.

It was a moment when my own affairs seemed in bad a state as they could possibly be. By leaving my mother I had forfeited all claims to her estate. At least that is what she made me understand, and I believed her.

It seemed to me that as long as the pyramids remained standing and Queen Victoria still reigned over her subjects, my mother would prove as equally invulnerable to time. But that very year Queen Victoria died, and soon afterward I read in the *New York Herald* the following paragraph:

Mr. St. Amar G. the brilliant son of
Mrs. Elle W. G. and Major Henry G. has died
at Nice of an illness that cut short a
promising career ...

A letter from my mother also announcing my brother's death followed closely afterward. In this she ordered me to return at once. I argued myself into thinking that there was a choice, but in reality there was none. After all, I said, if I now return to my mother and it fails again, I shall come back to Capri and work for my living. Have I not already painted four portraits?

But in truth I was extremely uneasy being aware that without my meager income things would be much harder than ever before. In this state of mind I packed up my valise and left behind hidden in a box the two hundred lire just received for a portrait of Mrs. Snow. It may come in handy one day, I reflected.

Before leaving the island the problem of finding a home for Maroo, my dog, came up.

It was Mr. Whipple who again proved his friendship. When he heard that I was leaving the island he came to see me in order to make up our difference. I spoke of the poor Maroo, and he at once offered to care for him during my absence. He asked me in return but one thing—a kiss. As I ungraciously offered my cheek I could not help thinking how unpleasant such a perfunctory gesture can be.

Later he sent me a photograph that is now faded but still shows two of his servants under a pergola, caressing my mongrel whose ugly bone structure is painfully evident; he had just been shaved to keep cool.

TURNING POINT

While in the train on my way back to Nice I found time to sum up my life, and the results were far from reassuring. So, after five years I am returning to my mother. I have not fortified my position in any way nor gained complete independence through my work. Such friends as

I have chosen are of no use whatever and particularly in an emergency such as must now be faced. I could have married, but to escape in that way had never occurred to me. It was evident that in spite of my tribulations I had not grown up, nor did I possess the slightest trace of what is called worldly wisdom. With these thoughts in my mind I fell asleep in a state of complete dejection.

The next morning my mood had changed. The train was now passing through the French Riviera, which I had not seen since childhood. Everything was of interest to me: the gardens overflowing with flowers or concentrated into dark tangled masses; the olive trees bigger and more gnarled than those of Capri. All was pleasant to the eye. Unlike the present day there were fewer ugly people about and no hideous posters and *guinguettes*.

THE MORTUARY CHAMBER

When I arrived at Nice I drove to one of my mother's flats on the avenue Victor Hugo. I was to know that in Nice alone she had six flats, for her mania was to shut up one when she had completely furnished it and then move into another. The cabman had placed my bag within the porte cochere and I was about to inquire my way of the concierge when, looking up, I saw a figure standing on the landing, facing me ... It was my mother.

I gazed at her, spellbound. She was untidily dressed in black; from under a blond wig that had shifted to one

side, gray wisps of hair escaped. Her face, which once merely quivered with madness, was now a rigid mask of madness and despair.

She did not greet me nor did I greet her; but beckoning me to follow her, she turned and entered the open doorway. Silently we both sat down on a divan in a room that smelled of death. The glaring sun outside had made me blind and though I knew my mother was inspecting me I could scarcely see her face. As the strange surroundings grew more distinct, I realized that we were in a sort of mortuary chamber, where the dim light cast a livid glow here and there on some white object.

At last my mother spoke: "This room is dedicated to your brother. His spirit haunts these relics of his deathbed."

Then rising from the divan and advancing to a large glass case that filled one side of the room, she began mumbling half to herself, half to me about its contents. There: the sheet on which he died with a cast of his hand placed upon it; and there: endless rows of death masks arranged in pairs and propped up so that each should face the other. "A duality in death," she murmured. She hoped this would help him forward on his journey to some astral sphere. I caught the word "lunar," which impressed me at that moment for it seemed to light with an unearthly glow my mother lost in a world of spirit-seekers.

All about the walls of the room were photographs, framed in black, of St. Amar on his deathbed. His beard

had been cut and his face appeared thinned to almost nothing. As often happens when in a dazed condition one's mind irrelevantly fixes on some trivial matter: at that moment it seemed to me that my brother's nose on the masks and photographs jutted out as though defying Death's leveling process.

As we moved about we would at times brush against what I took for a piece of furniture placed in the center of the room, but looking more closely I saw to my surprise that it was a bier. On a table nearby were flowers. My mother suddenly picked up a large bunch and thrust them in my hand. No longer mumbling she ordered distinctly: "You are an artist. Place these flowers in an artistic way round your brother's coffin."

I was far too bewildered even to wonder why she should have thought that it was my brother's coffin since his funeral had already taken place before my arrival. Paying my last tribute to St. Amar, I carefully laid the flowers in the form of a cross on the bier. Then looking up I found that my mother was no longer in the room.

THE BUTLER

Numbed by my surroundings I hastened out. In the corridor I met someone I took to be the butler. I asked him the way to my room and was surprised when he smiled familiarly as he answered that it was in another flat on the ground floor. I thought, decidedly my mother has

a very peculiar butler. He was rather stout, dressed in a tight frock coat with tails round at the back. His face, of course, was clean-shaven, but it was painted too ...

The following day I found out that this unusual person was not the butler but the celebrated Cheiro who was staying with my mother to help her communicate with St. Amar's spirit.

I reached my room and rested on the bed for a while, but the day was not yet ended. My mother appeared again at dinner. She ate seemingly without knowing that she was eating; and when she spoke it was only about my brother. Leaning over the table she would also occasionally place a hand over her eyes as if to rest. This also rested me ... till, with a start, I discovered, in the shadow and between the interstices of her fingers, a white eye staring out at me.

In my room that night I felt uneasy. Somehow I did not want my mother to appear unexpectedly. I sought to lock the door but there was no key. Being inventive I fastened one end of a piece of string to the knob and the other to the bedstead and then upon it balanced a log of wood. Had the door opened the log would have fallen and awakened me. Having done this I lay in bed, planning my escape, and then fell asleep.

But the following morning found me more courageous and I decided to see it through as long as it was possible. When I went to look for my mother I found she was in her room dressing to go out. She kept repeating something about it being the day of St. Amar's funeral,

for so in her mind she confused her visits to the ceme-
tery. She wished to go alone, she said, but before putting
on her hat she asked me which one of her many wigs
was best to wear at a funeral. To humor her I chose one
which she set on her head without looking at herself in
the mirror. She then left the room refusing my offer to
adjust it.

Walking down the stairs she talked to herself and
once outside insisted on following her carriage on foot
all the way to the cemetery as though it were a hearse.
When she returned she paced up and down inveighing
against the Riviera that had played her false by not bring-
ing health to her son. Then crying out that all life was
about to crush her, she beat upon the walls as if to push
them back.

Finally exhausted she fell on a couch and called
loudly for the maid who came forward and, as was ob-
viously her habit, knelt down and gently massaged her
mistress's eyelids and forehead. The maid seemed fright-
ened and kept glancing over at me as if seeking reassur-
ance. I responded by smiling ever so slightly. In a flash
my mother's eyes opened and stared intently at me.

Such scenes as these took place every day. The ten-
sion reached almost breaking point and the air was
heavy with impending tragedy. Sometimes I managed
to escape and would walk along the Promenade des An-
glais. Yes, the sea was there; the blue sky; people going
about quite normally. What did this existence mean?
How long would it last?

My mother seemed to be ill and as I was the only one who could act, I decided to consult a doctor. To him I first set forth her mental state but he answered that no measures could be taken unless she committed herself in public and there were witnesses to prove it. I then spoke of her general health and asked why it was that she drank such quantities of water. He wanted to examine her but as that was impossible he told me to bring him a sample of her urine.

The subsequent diagnosis of this showed that she had an extreme case of diabetes which at the slightest aggravation might prove fatal. This set me wondering how I could get the doctor in to treat her. One day, soon afterward, she complained of pains in her elbow. During a fit of anger she had knocked her arm against the wall. As the pain increased she ordered each of us in turn to massage her.

I stayed up most of the night rubbing her arm. Cheiro also came in for his part of this labor. He was quite willing to rub for hours, buoyed up by the prospects of a wedding when she would be well again. But under our inexpert care she grew worse; so without further delay, I called in the doctor I had already consulted. My mother was angry but as she was suffering she allowed him to examine her arm. When we explained to him that we had all been rubbing it for the past twenty-four hours he declared that in such severe cases of diabetes it was the very worst thing to do.

Her suffering grew intense and at times she became delirious. We knew that her blood was turning into sugar. She had such violent fits of vomiting that once, during one of these, her false teeth became detached and were flung across the room. When the doctor picked them up and did not return them to her, I saw her eyes questioning him.

She was a long time dying; her moods changed so rapidly that Death would stop his work and wait. But on her arm the red spot was now white and hard as marble. At length as she fell into a coma, as though Nature had intervened to bring relief, the doctor gave her an injection.

"We must do all we can to keep her alive," he said. "It is customary in case the dying have some last words to say."

She had indeed, and it was to me they were directed; words of intense hatred came pouring out. It was not delirium. She knew that she was dying and I, alive, watching. I wondered if such hate could die with death. Might it not, as earthborn *ombra*, always hover over me?

The doctor had left the room and my mother with her renewed strength was now demanding to be taken to the mortuary chamber. I was alone and had to help her out of bed. While she stood swaying on the floor she seized from off a chair a black silk jacket and, by force of habit, put it on.

As we neared the door she cried out that she could not pass. Pointing to some invisible obstruction she ordered me to push it out of the way. I humored her and made as

if to lead her round the obstacle while she clung closely to me to avoid touching what she saw.

I was barely able to support her weight along the corridor. As we entered the room, which had been neglected since my mother's illness, it seemed more abandoned than before. The light was shining crudely on the relics and the white plaster of the masks, and there were sharp shadows without depth of darkness anywhere. Surely no message could reach the dead from here.

My mother lay silent on the divan but she soon grew more and more disturbed as if vexed by some inner problem that found no answer. Finally sitting up, she cried out to my brother—perhaps he was not there—and then started to rave so wildly that I was frightened. As I stood behind the divan I tried by mere force of will to calm her. So long as I made the effort she seemed to quiet down but when I relaxed she would begin to rave anew. At last she fell back exhausted and I left the room to seek aid and have her carried back to bed again.

As the end drew near she was conscious only now and then of the presence of those around her. The timid maid who had trembled under the tyranny of her rule was now bold and triumphant. My mother sensed this change and once turned her head toward me with a mute appeal for protection. I sharply ordered the maid to leave the room.

That night as she suddenly sat up in bed and asked for a glass of water, someone whispered that she was not dying yet. But I had seen her clawing at the sheet as if some

force within her was impatient to be off. Besides, the dog in the garden below was howling dismally. What is it that they hear and see when Death passes by?

She drank the water and sank on the bed again. Then she made a gesture waving everybody from the room but me. She looked anxious, like a traveler who turns back to seek something he has left behind ... Unless he finds it, the journey will be longer.

Her opened mouth moved slowly trying to form the words that at first were incoherent. Then I understood ... she was asking me to forgive her. One tense moment ... as our eyes met her trouble deepened ... she was about to speak again when the door opened and Cheiro hurried in explaining that he knew that my mother wished to say something to him alone.

But she had nothing to say to anyone again. She only muttered to herself one of her own verses. Then shuddering, whispered: "But it is so cold; so cold!"

SPECTATOR

Her body had been laid out and there were candles round her. Death had left the face tormented. How curious, I reflected while looking at her, that before dying she made no appeal to the spirit world. Could it be that some revelation reached her during that visit to my brother's room?

I was lost in thought when the head maid, a tall, gaunt woman, came forward and bending down, kissed

my mother's face. As always, my role was merely that of a spectator. But the maid had her own views on the proper respects to be paid the dead. Seeing that I did not move, she whispered, "Aren't you going to kiss your mother?"

It was the whole world against me, but I shook my head. I felt no grief. My mother was only a phenomenon I had been watching fearfully all my life. Death, the climax ... nothing more.

FRIGHT

Too tired to go downstairs that night, I threw myself on a bed in an empty room and soon was asleep. Toward the early morning, I awoke with a start to find myself sitting up in bed, covered with sweat, my heart beating fast. I was about to cry out when a muffled sound, a slow, intermittent thudding on the door came to me. I knew it was my mother.

But I had been frightened while still asleep. What was it that escaped me on waking up? Surely something other than these hollow thuds, more like a deadened effort than sound. It had been my habit to wait patiently for my mother's moods to change; I waited then no less patiently until her ghostly visit ended with the night. At daybreak I rose and looked in the room from whence the rapping came. It was a bathroom. On the floor I saw scattered black silk underwear which my mother had

worn as mourning and which had been cast aside when they laid her out.

MADAME GUY

Cheiro, a very disappointed suitor, left Nice for Paris. Alone and needing someone near to help me, I called in the same lady companion who had been engaged to take me out walking five years before. She had never lost contact with my mother to whom she was constantly offering her services. Madame Guy arrived for the funeral. She was given the room in which I had slept the night before. Later in the day I left the flat with my bag, explaining to her that as I needed a change of atmosphere I would spend the night at a hotel. I chose one on the Promenade des Anglais. My room overlooked the sea and I fell asleep soothed by the waves beating on the shore.

But toward morning again I was awakened by the same indefinable terror that had preceded the muffled rappings on the door the previous night. Fortunately during that visit and the many others that were to follow, though at the moment I was unable to stir, my mind through force of will kept its even balance. This is perhaps the reason why in time I ceased to hear those ghostly sounds. Yet I was always conscious that there was still a haunting presence which inspired fear, though it eluded even the abstractions of a dream.

When I returned to the flat the next day I met Madame Guy at the door. She looked perturbed. I asked her if she had slept well.

"No!" she exclaimed. "Your mother visited me but I am a good Catholic; I was able to pray."

DEATH MASKS

After the funeral I passed a moment of bewilderment. Haunted during the night, I was confronted during the day with overwhelming evidence of my change of fortune. The cousin that directed the estate in America to whom I wired of my mother's death had wired back a hundred thousand francs. But before that I had found a small fortune: gold and silver coins piled up high and hidden in the corners of the cupboards. An old habit of my mother's, this hoarding.

So from possessing almost nothing I had now six flats in Nice alone, another in Monte Carlo, one in Dieppe, an unfurnished one in Paris, and a château near Mentone. Also there were trunks and wardrobes filled with clothes, furs, linen, and innumerable pieces of old lace. Turning over all these things I would unexpectedly come upon a plaster death mask of my brother. From off an upper shelf in a cupboard I pulled a pink satin sachet and out of it fell on my head one of these heavy masks. A large box when opened was found filled with more masks carefully packed in straw.

There were many small trunks each containing its specialty; one was filled with wigs alone, another with small boxes enclosing sets of teeth.

One day Madame Guy appeared at table looking very odd indeed. Her large mouth, always well filled out with yellow teeth, now fell in pleats as though deflated. Noticing my surprise she explained that she had found a *beau râtelier, tout neuf* with which she had replaced her own. I refrained from telling her that they were perhaps the same false teeth that had been projected across the room during my mother's illness. But I did offer her the whole trunkful of false teeth hoping she would choose another more becoming pair. She was delighted with the gift and afterward confided her intention of sending those she did not wear to a purchaser in Paris.

THE LAY FIGURE

Nothing in my mother's wardrobe appealed to me. I therefore ordered several plain tailor-made coats and skirts from Redfern's. But it was at a future date that I made my first important purchase: a life-size lay figure which traveled about with me, in a box made especially for it. It symbolized years of longing for the unobtainable, and, as is sometimes the case when our cherished dreams take form, it was never put to any use. Its dusty body, finally discarded, lay in an upper gallery of my studio. Another long-desired purchase was an elaborately

bound edition of Pater, which, to my surprise, I found far less agreeable to read than the old cheap edition.

THE DIARY

My mother's will dealt mainly with my brother, but it also revealed the fact that she never could have disinherited me as she so often threatened to do.

It was my grandfather's wishes that on her death the fortune should revert to his grandchildren.

Among the books and papers which had to be sorted there were many diaries locked, with the keys missing. These, when opened, showed fragments of her poems and also what seemed to be copies of letters or perhaps a special form of diary.

There was one tirade concerning my departure, a masterpiece of aloofness: "No doubt she imagines it very fine to sail away in a hoity-toity way having achieved the wonderful age of eighteen (which most young ladies are not at all delighted at)—hoping to cause great sensation in the ranks on hearing the Declaration of Independence. At that age we are supposed to have a little sense, some-times—although a good many postpone it indefinitely. But if the young woman really intends to go to London to see the Queen or to frighten a little mouse under a chair or to frighten (*sic*) 'the Thames afire'—why all this circumlocution and secrecy—if none can prevent her. In the meantime I suppose we are to live in expectation

of finding ourselves dazzled by a blaze of Glory, and to expect the Prodigal's return some day, perhaps bringing her own fatted calf to arouse our humble envy.

"The heroines of old-fashioned novels often underwent the most thrilling adventures and narrow escapes through three volumes, in the same white dress, so it is to be hoped a spotless robe will be the ornament of our 'Clarissa Harlowe' through a siege of ardent 'Lovelaces.'

"But nowadays *nous avons changé tout cela*, for the breeches-wearing and bicycle-striding bold and vulgar *fin de siècle* female needs no petticoat at all. She tears around the world an unmasked battery on wheels, and her fair disciples are found everywhere following their own 'lesser lights' as fishers of men—mere excrescences of egotism and selfishness ..."

RIVIERA JUNGLES

There came a moment when I was completely submerged in some fantom world. Vainly would I thrust aside shadowy curtains that fell and clung around me preventing advance or retreat. My newly acquired fortune did not interest me, nor in fact did anything connected with the material world.

In this abnormal state of mind I would drive out to some quiet spot, leave the carriage, and then wander up narrow paths or along hidden roads where one could peer into the tangled mess of neglected gardens.

These enclosures seemed to contain a force striving for isolation and in the effort giving out poisonous self-protecting scents.

There the magnolia trees half-flower, yellow and spotted black—their scent without sweetness might kill. The tawny and ragged eucalyptus trees mitigated, perhaps, with their medicinal fragrance the poisons of decay that corrupted the earth. Gray-bearded palm trees, resembling huge primordial apes; others like Indian fakirs meditating with unbound turbans trailing around them seemed indifferent to their slim companions rising high in the air with leaves like plumage waving in windblown exultation.

Within these parks there can be no human joy, I muse, only triumphant unity of living and decaying nature with the black forces of the earth. The sun never penetrates these dense masses nor can it touch the pale leprous house lost in their midst. What hybrid creatures live there, I wonder. Their shell another's cast-off diseased shell; savage natures whose lairs savage nature covers; leprous souls flaked by the scalings of leprous walls; or perhaps dual natures seeking impersonal union with darker selves. Who knows?

As I breathed deeply the poisons seeping out from the rusty gates, I found myself drawn away from the outer world by the magic of these mysterious Riviera jungles. When I returned to the château, Madame Guy would loom up like a familiar monster, a revenant of my childhood days. Then she, who was not haunted, would re-

monstrate with me, saying that I was becoming like my mother. I resented her intrusion into that other world which held me in some strange way.

But one day, she spoke of my art. "Aren't you ever going to paint again?" she asked. Her question startled me. Of course I am going to paint again. How was it that I had neglected for so long the only thing that really mattered? Not long after this I was even making plans to go away in order to begin my work. It was a victory ...

CAPRI AGAIN

Before going to London I visited Capri once again.

It was during this visit that I gave up the studio which had been my home for four years. When for the last time the big rusty key opened the door of the old chapel, I felt very unhappy. I knew somehow that the simple, almost monastic life so congenial to me was now over. I packed up my few books and canvases and thrust into an already bulging pocketbook the two hundred lire which I had left behind in a box. Then, with a last glance round at the rickety desk and its high stool, I turned away from all that had made up my life as a poor student.

For the new life awaiting me I was ill prepared.

My next move was to see my unfortunate friend whom I had left in so desperate a state, so as to help patch up his affairs and by so doing to give him a new lease of life as he then called it.

I found him living in a villa so neglected that it was overrun by a species of ticks whose proper homes were outside in the garden. When lunching with him I could see these blood-sucking insects freely crawling up the legs of the table, and his dogs were no less covered with them. I had a horror of that particular Capri insect, and if only one found its way into my own mongrel's furry coat it took all my courage to finally pinch the swollen rubber bag of blood and then twist it out of its tight hold in the flesh. A house full of these was nothing less than a nightmare. But Mr. G. had never tried to rid himself of them. Up to this very last moment of his financial despair he would pass hours a day swaying on a piano stool as he interpreted intricate musical compositions with the emotional inexactitude of the amateur.

PRESENTS

At that period I was fairly aglow with generosity. I gave presents to all and sundry. Mrs. Snow came in for a chatelaine with its many odds and ends dangling on a chain.

Uncle Charley received a tidy sum for an ugly Renaissance hanging. This imposing expanse of silk and velvet was highly embossed with a huge coat of arms. "It is a museum piece and belonged to some doge," explained Uncle Charley. Secretly I wondered whether the doge had lacked good taste or whether it was I who was wanting in a proper appreciation of just such works of art. I could

never get used to it, and as Uncle Charley had considered it so very valuable, I ended by sending it back to him as a present.

Of course my closest friend came in for all my solicitude. At that moment his personal belongings were being sold for his daily bread. Mrs. Bertram-Smith bought a lantern and a painting of his garden, which incidentally, she tried to make me buy back when, later on, she was on bad terms with him. But now it was no longer a question of mere presents; all his debts had to be paid off and an income supplied if he were to continue living in Capri. Why I should have thought it up to me to see this project through is now hard to understand. Perhaps I dreaded that my fortune might push me into the detested conventional life, and this made me cling to what belonged to my student days. I was anxious to begin my work. An inner state of distress still haunted me and demanded just such an outlet. The death of my mother and brother had not liberated me mentally, and I felt that some part of me still remained with them.

THE WALKING TOUR

It was also at that time that I decided to forego the many hateful prerogatives of my sex, the complexity of female clothes for instance. It would now be possible to live the simple life garbed solely in male sport attire. Then a long walking tour from town to town burdened only

with knapsack and sketchbook would do much to bring back a more normal state of mind.

So intent was I on enforcing my views about this walking tour that I went on making plans and, while on a visit to London, I spent many hours in "Our Boys Shop" so as to be sure of ordering for myself a genuine sport outfit which would have been none too easy to find for a girl in those days.

I cut off my hair and finally when ready for what I hoped would be my future life I showed myself to Mr. G. He was horrified, exclaimed against the baggy trousers, big shoes, and badly cut hair, and then remarked that in my company his reputation would be forever damaged.

So there were to be no walking tours with knapsack and sketchbook, no help in my efforts to escape the conventional. I could but choose to face the future alone.

LONDON

I went to live in London at the end of a very interesting period. Whistler, Oscar Wilde, and Beardsley were dead, but an afterglow brought into relief such figures as Conder, Sickert, Max Beerbohm, and others.

Sargent lived in Tite Street in a house opposite to mine, but as his work did not interest me I never sought to know him.

Charles Conder was a tragic figure. He had worked for many years in Paris and there had acquired the habit

of drinking absinth; so that the natural ramblings of his mind became even more incoherent and obscure. I recall his long pale face, lanky hair, and low voice ever murmuring disconnected mysteries belonging to a Balzac world of his own. When I first knew him he had just married and his wife was supposed to be curing him of his absinth habits. But it soon came to be known that the lady herself seemed to be a victim to some awful propensity.

Whenever I went to visit him at his studio, Mrs. Conder would appear at the door with some part of her face bandaged: either the eye, the nose, or the forehead. It was most perplexing as there could be no question of the gentle Conder being at fault. But soon the mystery was solved: it was said that this lady had epilepsy. When seized with an attack she would fall hurting herself against the sharp edges of mantelpiece or furniture.

The effect of absinth on Conder could be but mild indeed compared with the harm these fits were working on the artist's sensitive brain. It was most harrowing and I discontinued my visits. One day, however, a very agitated Conder came to my studio and amid such confusion of words I understood that he was seeking refuge with me from his wife. I comforted him as best I could but the lady with the bandaged face so terrified me that I managed not only to curtail that particular visit but I was never to be at home for him again.

I felt keenly about this tragedy for I knew that Conder was doomed.

Shortly afterward I believe he was placed in a luna-tic asylum, where he died, and some years later I heard that his wife was burned to death while asleep, her bed having caught fire from a lighted cigarette.

THE PERUGINO HEAD

It was when installed in my Tite Street studio surrounded by an artist's paraphernalia—all the things I had been unable to possess before: a fine lay figure, a tall oaken easel, and plenty of new paints and paintbrushes— that I began harboring doubts as to whether all was well with my work. What had I accomplished? Surely nothing more than a student's work. I reviewed my can-vases; these showed distinction only in that they all ex-pressed uniform melancholy. Roman models in spite of gaily striped shawls and jaunty headgear were pensive and sad; the sun-tanned Capri peasants expressed no less such introspective moods. Perhaps certain heads painted without models were the best, but in those days independent work of the sort was taboo, "not serious."

There was a painting of a young man's head by Peru-gino which I had copied while staying at Florence. I re-membered the incident.

It had been chosen by me because of its sad expres-sion and also because it hung on the walls of a small and secluded room of the Uffizi Gallery. I had never copied a picture before and being far from sure of myself I hoped

to escape the attention of the many tourists who, when passing through the important rooms, stopped to gaze no less at the copies than at the genuine works of art.

On arriving the first day to begin my work I found to my dismay that the custodian had unhung the small picture and placed it on an easel in the very center of one of the biggest galleries in the palace.

I spent some very hot and uncomfortable moments as I worked in that large room. This picture was of no value to me but several years later d'Annunzio liked it so much that I gave it to him. Afterward he told me that my copy had been taken for a genuine *quattrocento* and on one occasion he could have sold it as such to the Comtesse de Béarn.

But to return to my studio in Tite Street. I was so dissatisfied with my work that it seemed to me useless to go on painting at all unless I could begin anew and forget all the many self-made rules which were impeding progress. "Paint only what you really feel" I kept repeating to myself. The result was still another melancholy self-expression: a young man with head bowed over a pink tie and evidently in the last throes of dejection. But it so happened that this head was accepted for an exhibition, and even such light success as that brought encouragement.

I was accustomed to the vivid colors of southern Italy and I now found that my palette lacked range and subtlety of tones. This was a defect that had to be remedied. St. Ives on the Cornish coast seemed indicated as the very place where one could study an ever-changing

opalescent sea. It was there that eventually I spent many hours training my eyes to detect and my hands to note down an endless gamut of grays. This work was congenial to me and at times brought its reward by enabling me to paint a tone I could scarcely perceive.

I was happy at St. Ives, for it reminded me of my student days. When the weather was boisterous and the tide high, waves would dash up against the walls of my studio and even over the roof.

I had meals at the small hotel of the place and there met other artists who invited me to their studios to see their work. They all specialized in painting views of the port with its boats and fishermen. [These] subjects held out no interest to me, so when they in turn asked to come and see my work I was at first most reluctant. Now why I finally changed my mind is hard to imagine. I lined up on my mantelpiece a dozen or so of the small pieces of cardboard showing each its successful or unsuccessful gray attempt. There were no boats, no fishermen, and, as was to be expected, my guests finding nothing at all to look at soon trooped out of my studio in silence. I had been judged half-witted by them and I knew it; but as usual I preferred just such depreciation where there could be no possible converging of views.

Of all the painters of that period, I of course admired Whistler most. I also criticized him long before I was able to express my own personality in painting. I wondered at the magic subtlety of his tones but thought his "symphonies" lacked corresponding subtlety of expression.

There was no surprise, no paradox, no complexity. His was a painter's perfect technique expressing delicate visual beauty. My own disturbed temperament was to aspire toward more indeterminate moods.

It was said that Walter Sickert regretted his long apprenticeship to Whistler, but his works had a decided character of their own. I have a picture of his, a doge's palace, that none but the Sickert of those days could have painted. Carrière's misty effects seemed to me woefully commonplace. What interest could there be in those strapping though anguished mothers nursing equally strapping babies enveloped in the steam of the weekly washtub?

Conder ended exquisitely an art period in England that had but little more to give. His gossamer-like lines held together a dreamer's dim memory of color. I have several of his delicate paintings on silk. Will they survive to remind some future generation of a period in art which may by then be almost impossible to evoke?

Memories of my stay in England are not altogether unpleasant and probably this is because I found myself among artists and that I avoided as far as was possible the tribe called Society. I still held the view that these outsiders with their false values invariably took unfair advantages over those who had no family rocking chairs to fall back upon.

It was about this time that I met at Robbie Ross's Lord Alfred Douglas. His extreme youthfulness surprised me: blond and boyish, his face showed no signs of recent

upheaval, no drooping lines of bitterness. Perhaps he saw in me a dark edition of his own unquenchable youth hiding a like rebellion against the world and its censure. I certainly saw in him a *lapidé*. How could it be otherwise ... a friend of Oscar Wilde. To me the attraction lay precisely in that direction. During our friendship Lord Alfred showed none of the bitterness he was later to reveal from so unexpected an angle.

Looking backward I see myself as failing to identify my youthful friend with the exquisite poet of "The City of the Soul." Perhaps my own problems were too absorbing to allow of a more receptive state of mind. Besides, whenever I deserted solitude for friends did not a more discerning and deeper self invariably desert me? So it was only on the common ground of attraction I could meet others. Bosie would often say, "How is it that we never met when I was in Capri?" I now ask, "How is it that we never met at all?"

But it may be that my memory is at fault. Did he not write in his book of poems "To Romaine from Bosie": "Nous avons souvent dit d'impérissables choses." So perhaps we did say these things, perhaps we did really meet. I say "perhaps" for why then does there still cling to my memory, more closely than anything else that happened at the time, a definite feeling of guilt for having abandoned my work even for so short an interlude. But such is the fact.

I was unaware that the pleasurable side of human relationship would always elude me. Whatever reasons I

gave for ending just such adventures they were but pre-
texts to allow of a speedy return to the other self—the
worker.

THE SHADOW

There comes a moment when our dead seem at rest; their
efforts dulled, their presence no longer defined. But if
they are gone, what is the shadow that turns from night
to confuse the day. Surely our ghosts are still there. They
need be manifest no longer for they have found their way
in, they are now one with us. This double self is strong to
dispose even though we may think ourselves the master.

How is it that I failed so completely to carry out my
plans? Surely I despised all worldly values and desired
only to live and work quietly. Yet, looking backward, I
see myself caught in a mode of life that perforce was to
make of me a victim.

To concentrate upon some particular work may leave
us unequipped for others. The more I applied myself to
giving a form to my art, the more unable was I to ma-
neuver with skill when thrust into what was to prove a
veritable arena.

However, I was making strides in my work. I had al-
ready painted a series of solitary figures that had of life
only the camouflage of exaggerated attire. Possessing for
the first time sufficient means, and no longer interested
in medieval English decorations, I began to arrange my

house in Paris without paying attention to the fashions of the moment. I was intent only on expressing personal moods and by so doing to prepare "ensembles" which could be painted in my pictures. It was usual in those days to follow slavishly some given period of decoration. I chose from all periods what could help to form massed shadow effects on light misty backgrounds. Each ensemble had its white accent which sent the half-toned figure back to a second plane. Colors I used only to show up these halftones which alone interested me but which doubtless passed undetected by the less practiced eye.

I never thought to attract attention or to astonish by this fever for arranging things. It came quite natural to me. I was only trying to make my surroundings coincide with some disturbing significance within my artist's brain.

If later on I painted no longer in that peculiar fashion it was because I myself had changed and taken on more definite outline. But at that time it was a spontaneous expression and I could have painted in no other way. With me it had always been a question of moods not of modes.

CURIOSITY

I have seen at the cinema a picture of an underground animal whose burrow is uncovered on one side to allow inspection of him as he goes about his work. Curiously enough he is completely oblivious of the high-

lights thrown upon him and of the peering eyes of the photographer. Such was exactly my position in Paris. For a long time I remained unconscious of the curiosity that brought people to stare at me. For them I was young and rich but for some dark reason I was always hard at work and alone. What did it mean?

As usual there was a predominance of *gens du monde* ever seeking diversion and trouble. They would come and ask advice concerning such things as lampshades and cushions and I willingly met them halfway, although I was only interested in some general scheme of decoration.

I even painted several of these society women, and when they were well pleased I gave them their portraits.

I had yet to learn that to give a portrait to a sitter is a sure way of making an enemy. After the first prehensible gesture, how incredibly slack and hostile they can become. The ungenerous-minded are in a constant state of vexation caused by their own meanness; so the degree of admiration they feel for a gift can be easily gauged by the amount of hostility they show to the giver.

Like some curious animal in a cage I was at first stroked and admired, then jeered and jabbed at. Mere curiosity was to turn into mischievous prying. Ugly noses were thrust into my private affairs which by reason of their peculiar character could not escape comprehension. Huge ears were catching up every word I said, and rattletrap mouths repeating these in such fashion as to do me as much harm as possible.

It is a pity that envy and malice fail to see the reverse of the medal.

Notwithstanding appearances I was so handicapped in many ways that any form of social life was difficult for me to follow. I had very little memory for most things and for names I had none at all.

The very intentness with which I focused on certain faces that interested me led to my classifying all the others, and thus causing annoyance to those who resented being mistaken for someone else.

My brain refused to be interested in French or Italian, though these languages had been easier for me to acquire than English since my education in this language had stopped when I left America at the age of twelve. But it was English alone that interested me and I could read and study it in all free moments.

Letters addressed to me expressing appreciation of my work, invitations, and so forth remained unanswered. I simply balked at such long formalities as "je vous prie d'agréer l'expression de mes sentiments les meilleurs" and others of the same sort.

Old Lady Anglesey sent me a French secretary who, she said, would do all my writing for me. But the mild-eyed, middle-aged woman proved to be as rebellious as I was against *les usages du monde*. Did she not copy out from my address book the abbreviated forms of names and titles and write these on some fifty envelopes containing invitations to one of my shows. I had to rewrite them all again, for this gentlewoman showed decided

obstinacy when told that such abbreviated forms of addresses were considered impolite in France.

Soon much of my time was spent in a large barnlike studio which I had rented far away on the left side of the river, and my Trocadéro home became a sort of storehouse wherein accumulated endless obligations, which were never attended to, and which made up my much detested form of life. Though I still held that what was particularly disagreeable had to be carried through, I am sure that I should soon have liberated myself had there not entered my life at that very moment a new element which made me follow more consistently than before the ruts of society.

Shortly before leaving London I met an American woman who had married into an old French family and whose home was in Paris. She was some ten years my senior, and as she was well versed on subjects pertaining to art I was grateful for the interest she showed in my work.

She was also a good musician, and her forcible character and dry American wit went to form a personality which had little in common with the title she bore. I would wonder how she could possibly care for a borrowed remnant of other days, but soon I was to know that she valued this remnant far above all else, and that she willingly cramped herself to fit its form.

I became attracted to what could offer no possible means of approach.

I am now looking at what remains of a torn photograph. The profile alone is intact—even so a cherished

memory which a last feverish gesture cannot destroy. The head is bent forward with profile emerging from out of a profusion of dark hair. The lowered eye escapes detection. The nose is arched and noble, but the mouth with its protruding lower lip shows strong atavistic ruthlessness ever active in self-defense. Even now musing over this photograph and the memories which it evokes brings perplexity. If I remember well there was little else but this striking though ambiguous face to justify my obstinate pursuance of this friendship. Nor was there any reason for the resentment felt when I found myself left completely outside this lady's fairy tale of life, wherein only queens, princesses, duchesses, and a few witches had the right to parade about, while such small fry as geniuses, artists, musicians, and the like were called in solely to divert and entertain these higher beings.

There was no possible converging of views unless indeed I transformed my whole nature, I who admitted no hierarchy but that of the mind.

Fortunately I refrained from revealing my superstitions concerning my dead mother whose willpower was still alive, I thought, and hovering about to harm and drive me in contrary directions. When made particularly unhappy I would attribute my state to the fact that this inimical power was now embodied in my friend and at times I even thought she resembled my mother.

The admiring sympathy which I felt for *les lapidés* and the fact that I considered myself one of these were also subjects never broached upon, nor did I express

opinions about the many titled people I was now meeting, and who struck me as garrulous bores with none of the old-time spirit of *noblesse oblige* which had evidently gone out of fashion. So our thoughts never met; she to remain arrogant and snobby, and I angry at my own inconsistencies. Yet I was decidedly under this influence and in order to impress my idol I would open my doors to all the title-bearers I could possibly muster.

As there was much curiosity about me, soon my salon was filled with genuine or otherwise marquises, princesses (witches included), and even grand dukes and duchesses. What more could I do? But there was more to do. While staying at Carlsbad with some society people I was presented to King Edward VII of England. This presentation was made possible through my acquaintance with a certain Spanish duke whose attentions I accepted only so far as my obsession for my American friend allowed.

THE PHOTOGRAPH

Photographs are excellent reminders of the past and I smile as I look at a photograph taken of me during that period. I am attired in the extreme elegance of nineteen hundred and four. My long white dress is enriched with embroidery, and my hat, perched on a mass of curls, is ornate with flowers. One end of a long black veil sweeping over the hat falls below the waist, and the other end

is looped gracefully over my arm. I am holding a parasol. My face shows no expression whatever, such vacuity being the true aim of all fashionable photographers.

But is it possible that only a short time before this I had vowed never to wear anything but the sports suits chosen at "Our Boys" in London?

THE TEA PARTY

This photograph shows how I was attired when presented to King Edward VII at a tea party given somewhere near Marienbad.

I knew that this adventure would enhance me in the eyes of my socially ambitious friend so it was with no reluctance that I accompanied Sir Henry Ponsonby and Admiral Fisher on the drive through the forest leading up to the hill where the rustic tea party was to take place.

Among the other guests already assembled there were the Duke d'Alba and a very handsome American girl, his supposed fiancée.

The king arrived and I made my courtesy.

During the tea, so far as discretion allowed, I took note of his personality. This thickset, ruddy, middle-aged gentleman bore himself with the greatest dignity. His was the "limited perfection" which every English gentleman would achieve. I remarked that his eyes were intensely blue, but they were opaque and without luster.

He observed with interest everyone and everything.

When he looked in my direction I felt that I had been summed up with the most royal inaccuracy possible.

I was seated next to Lord Admiral Fisher who by way of conversation told me that the queen called him "Jacky Fish." On the table in front of us a small vase loaded with field flowers suddenly toppled over. Jacky Fish made ineffectual efforts to redress it. I then came to his aid and with one vigorous gesture fairly forced the case to regain equilibrium. The king, who had been watching us, exclaimed to Admiral Fisher, "We always need the aid of the ladies, don't we?"

After tea the king came over to where I was standing and spoke to me.

He had heard that I was an artist, he said, and then, what did I think of the Royal Watercolour Society? I had never heard of it before, but rising to the occasion, I answered that I considered it ranked very highly indeed. The king seemed pleased and then asked whom I was painting at the moment. I mentioned having just finished a portrait of Madame C. L. He knew her and evidently some thought amused him for after repeating her name he laughed heartily. Without knowing precisely why I laughed too.

Before leaving my side he expressed the wish to see my exhibition when I should give it in London.

That very evening I wrote to my friend describing the tea party much as it is written here. Her immediate reply was most satisfactory showing as it did a greater appreciation of me than ever before.

The self-imposed battle games of society which I fought and played so badly failed to conciliate the only one of its members that I cared for. It was as usual through the medium of work that I found relief and the disconsolate figures which I painted at that time clearly show the troubles that were agitating me. That such subjective paintings should have found outside appreciation came to me as a surprise. But such was the case.

Monsieur Georges Durand-Ruel came to see my work and then invited me to give an exhibition at his galleries. This was a great honor for the Durand-Ruels showed only the best work of the times and specialized in the impressionist schools of painting. Personally I never thought about schools at all and certainly I was not an impressionist, for I worked entirely indoors and my few landscapes were painted from memory.

I was very elated while arranging my exhibition. I had all the red plush walls covered over with a simple beige stuff and then hung up my pictures to their best decorative effect. But when all was finished and I surveyed the array of sad, introspective figures recalling as they did my own moods, I had a strong revulsion of feelings. How was it possible to expose in such fashion one's inner self to the world? I felt no less nude than were the nudes on the walls. Were it possible, I would have had given orders then and there to have my paintings taken down and sent back to my studio.

The exhibition was a success.

The preface of my catalogue was written by Monsieur Roger Marx and there were many newspaper articles by all the best critics. Comte Robert de Montesquiou, whose friendship dates from that time, wrote a long article.

It was precisely because I felt trapped that I grasped at every occasion no matter how small to assert my independence of views. I refused to accept slavish traditions in art, and, though aware that it would shock, I insisted on marking the sex-triangles of all my female nude figures. The traditional depilatory effect shocked me, so I discarded it altogether. This show of independence evidently helped to condone the many concessions I made in other directions.

My exhibition had brought me into the limelight and I was now an easy target for all those who would not accept what seemed to them an unfair distribution of things. I remember meeting Boldini at a fête. Looking at me with ill humor he said, "Quoi avoir des bras comme ceux-là et savoir peindre!" I sensed his antagonism and concluded that Boldini would naturally prefer surface values for women. Even his earliest and best paintings show that he could paint only these.

Without exaggeration I can say that during that particular moment of my life I had neither friends nor pleasant outside relaxations of any kind. What I called grown-up games, such as teas, dinners, receptions, and such like, bored me intensely. As time went on I even

stopped going out in the evenings altogether. I would draw the curtains at the close of day and retire to my library. There for hours at a time I read and studied and tried to be as happy as I had once been in Capri.

I already knew that my love for books and study could never be assailed. Indeed, it was with the very stones that were finally flung at me that I built up the strong walls of this inner sanctuary.

RETRIBUTION

It now astonishes me that I was not more wary of people. I had no need of them and, besides, so much real trouble had come my way that though petty scandals and malicious intrigues could not harm me they did make me extremely angry at times. After all I was planning escape so why did I choose that very moment to begin a portrait of a young woman who was par excellence *une femme du monde*? It is true that she made efforts to be friendly and wanted very much to be painted. She possessed what is called *un visage spirituel* and as I had no particular liking for just such faces, there was no justification whatsoever for my painting that portrait. No wonder that retribution awaited me round the corner and at no time was it more richly deserved.

Between this young woman and me there was not one thought in common; yet I allowed myself to be drawn into her equally incompatible circle of worldly friends.

Recollections of her family, however, remain distinctly apart. It was one of the oldest in France, and in contrast to the attitude adopted by my American friend, they showed strong predilection for artists, even so far as to affect being artists themselves.

The old marquise wrote poems that possessed an expression all their own: though aspiring to the highest lyrical fancies they managed somehow to convey another equivocal meaning. She also painted flowers. Her devotion to painting was such that she gave to it all her odd moments, she would say. It left me breathless, this casual disposing of an art that had always been to me so exacting and tormenting a master.

But if these people were ineffectual when aping artists they were certainly capable and dignified when following their own line of life. Their hospitality was Maecenasian; their inborn courtesy truly French. They made much of my portrait which hung in one of their reception rooms and, being an artist, I was always received by them as an esteemed guest.

MONSIEUR H.

It was while in that circle composed of ambitious writers, artists, and especially mondaines that I met Monsieur H. This meeting would have remained casual had I not desired to please my French friend.

At that moment I was deeply interested in the Russian

dramatists, those great artists who are held not by reality alone but rather by its significance. The dramatized platitudes such as made up the writings of Monsieur H. were in my opinion devoid of interest; but one could not escape the all-pervading pan-rattling self-eulogy which was his way of catching the dull ear of the indiscriminate. This playing up to the majority being perforce the highest aim where there can be no other.

Monsieur H. was a giant and not over-pleasant to look at, with his big features jutting forward from rounded shoulders, his green complexion, long arms, and trembling hands. But he had a great opinion of himself and there were certain women who shared it.

When I was asked as a favor to give this gentleman advice concerning the decoration of his flat, though disliking the idea intensely, I ended by accompanying my friend to his rooms.

I held that a person's surroundings should be a reflection of his own personality; that it mattered little whether it be in good or bad taste provided it showed some psychological interest of the sort.

Now Monsieur H.'s bourgeois flat overloaded with ugly pretentious Empire furniture suited him perfectly.

The poorly proportioned bedroom with its great canopied bed, the columns and steps leading up to it; the tiny bathroom with a conspicuous white porcelain bidet in the shape of a swan (shown with great pride), all this and everything else was in the worst taste possible, but as I have already said it was well in keeping with Mon-

sieur H. and so there was no reason to make a change. However, I was there expressly to give advice and what was more this had to be in line with my own moods of expression. Probably the thought exasperated me, for I ended by telling him that it was impossible to suggest anything until he had emptied his flat entirely and given away to his concierge all the ugly things it contained. It was drastic and I hoped to end once and for all this disagreeable business of giving advice.

But no! Shortly afterward my friend informed me that her poor friend was in a quandary: he had emptied his flat as advised but now he had no idea how to refurnish it. This meant two more visits. Knowing how futile it would be to touch on such subtleties as intervening tones, I set Monsieur H. in the dangerous direction of blacks and whites. Besides, was it appropriate that he should nestle in the mystery of grays?

My last visit to his flat was to see the final effect.

Consistent with my theory that personality should be expressed above all else I fully approved of the crude and spectacular interpretation given to my suggestions. Everything was done to *épater*. Even the menus were written on slates and during the luncheon the dining room door opened and in walked a big dog, a black-and-white Dane.

Then to show how effective he was in his new surroundings, Monsieur H. seated himself before a large black lacquer desk and sharply superposed his huge crow-like silhouette on to the light walls.

How could one possibly foresee that, with a total lack

of intuition, he was to anticipate playing a role with me other than that of an admirer of my views on interior decorations. But such was the case, and he chose my pygmy hostess of the salon littéraire to be his emissary. My ideas about marriage had not changed. Had I not withstood all efforts of my American friend to make me worthy to enter her fairy land by means of a princely or "fairy" alliance.

My refusal to be mated to Goliath—none too gently worded perhaps—was regarded as an insult not only by the pygmy hostess and her salon littéraire but also, as time went on, by many other circles of Parisians. It was, however, only a long while afterward when faced by this growing hostility that I seized the connecting links.

LA TOUR EIFFEL

I was now painting Jean Cocteau. He had written a poem on the Tour Eiffel. This colossal steel structure had ushered in the machine age and was now boldly defying a city of low uniform lines. A rebel that fascinated me, it could be seen from my terrace and I decided to paint it in Jean Cocteau's portrait.

"How can you paint anything so hideous when there is a beautiful Palais de Versailles?" I was asked.

To me the Palais de Versailles was not paintable. Its classical dimensions were too cold, too empty even to harbor ghosts.

By painting Jean Cocteau I was to forfeit Robert de Montesquiou's friendship to some extent. I knew that Montesquiou wanted his portrait and there seemed no plausible reason for my not painting it. But there was a reason. In my opinion he was crystallized like the Palais de Versailles. He contained nothing that could be remade to my making. Boldini had already painted a remarkable likeness of him; there were no hidden complexities, nothing left for me to do.

Robert de Montesquiou disliked Jean Cocteau. It was the *lettré*, the aristocrat versus the clever, ultra-modern young *arriviste*. Cocteau delighted in belittling everything to fit his own pattern. He had a gift for imitating others and was particularly successful in his mimicking of Montesquiou. This was not hard to do, for Montesquiou had many mannerisms, but unlike Cocteau he contained no venom and his shafts were directed mainly against the pretentious writers and so-called poets and poetesses of his own world—the old marquise of whom I have written being one of his targets.

Now Montesquiou had seen and heard Cocteau mimicking him. It was only too evident that there could be no friendship between the two. Yet Cocteau insisted on bringing this about and even asked me to intercede for him.

I had just finished painting Cocteau when Montesquiou visited my studio. On seeing the portrait he exclaimed angrily: "Comment, il est arrivé tout de même à avoir son portrait!" Then he drew from his pocket a small

wooden toy: a funny little figure rounded at the bottom like an egg but balanced in such fashion as to remain upright. Placing it on a table, he hit hard at the little figure, which rolled and wobbled about without toppling over.

"Voilà! Il est comme cela, le petit bonhomme que vous venez de peindre!" exclaimed Montesquiou.

Cocteau posed on my glass-covered terrace overlooking Paris. He stood leaning against the railings, the Tour Eiffel and Grande Roue seen in the near distance. He was finicky about drafts and took such refreshments as café au lait and chunks of American layer cake.

I knew little about Cocteau, curiosity concerning others not being one of my failings: but soon, instinctively, I did know that we moved in diametrically opposite directions; that he was no *lapidé* but rather that he sided with those who threw the stones. I painted him a concave figure standing as it were at the bow of his ship listlessly zigzagging its course. At a later period I might have painted him differently, for I was then to know that his course was directed toward the nadir, the nadir with its fallen star.

AUNT MINNIE

I should have liked to paint old Lady Anglesey—Aunt Minnie, as she insisted on being called.

I saw her for the first time at Versailles. She was seated a pale and delicate old porcelain figure amid clusters

132

of pale and delicate white porcelain flowers—these a collector's whim and covering the walls and tables of her salon.

She was American with the most finely chiseled and aristocratic face possible. She also possessed a distinctive elegance which is rare in our generation. Conversation with her was something not of this world, for with each slight puff of her breath, feathery thoughts were wafted from place to place defying any point of contact. Not for a single instant could she concentrate on one subject. A vocabulary was not necessary, mere chirping and twitting had answered just as well.

She was willing to pose for me if I painted her as she looked when at the age of thirty, she would say. To my mind the well-known portrait of her by Boldini showed that when young she had not the beauty which age had given her. I continued visiting her at Versailles for I still clung to the idea of painting the portrait.

It was clear that Aunt Minnie had not the slightest comprehension of me, nor of my work. In her eyes I was a frivolous mondaine like herself. But what did it matter? She was beautiful to look at, and besides, only one part of me ventured out on these excursions; the other deeper, rebellious self I carefully left behind at home.

Now Aunt Minnie was an inveterate matchmaker and before long she was trying to fit me into one of her harum-scarum matrimonial schemes. With woeful lack of perspicacity she had planned a marriage between me and no other than Don Jaime, the Spanish Pretender. I

remember this nobleman as being always followed by a suite of dark and mysterious-looking Spanish priests.

He sent me as a present a valuable but to my mind ugly red silk Oriental carpet. Not knowing how to refuse it I hid it away in a cupboard for the time being.

One day Lady Anglesey asked me to accompany her to see Don Jaime's portrait on view at the studio of a Spanish painter. On the way she kept reminding me not to forget to make a curtsy when presented to the arch-duchess or some such titled person who was to be present. I assured her that I would follow her and curtsy whenever she curtsied.

On entering the studio we saw standing in the center of the room a handsome and stately lady who could be no other than the arch-duchess herself. Aunt Minnie made her curtsy and I followed suit, whereupon the lady curtsied to each of us in turn. She proved to be the artist's wife, and when the real arch-duchess arrived she was neither handsome nor dignified and perched high on her head was a straw sailor hat trimmed with daisies.

When the guests were assembled the Spanish painter approached and silently presented to each of us in turn a microscope together with a slip of paper on which was written a request to inspect the portrait carefully. When my turn came, going up to the portrait I looked through the microscope and was duly impressed to see that each single hair of the eyebrows and eyelashes had been painted with the utmost care.

But no one congratulated the artist. Aunt Minnie whispered that he was deaf and dumb.

On our returning to the carriage Don Jaime held up his feet to show that he was wearing shoes that did not match. This amused him very much and we all laughed with him. I was even inclined to laugh too much, but this was due perhaps to other causes.

Shortly after this eventful day Aunt Minnie expressed the opinion that I should return to Don Jaime his red silk carpet.

A STRANGER

By nature a stranger everywhere, there could be for me no conforming to any definite trend of life. Even success as an artist was in my opinion a form of compliance; it held down and bound one to what should have served merely as a means of escape. I had lost touch with my former aspirations without having formed new ones to replace them. Was the exultation of rebellion to lead only to this anticlimax, to breathing the heavy air of the hot house wherein artists and writers were too smug, too cautious to become either great saints or great sinners. *L'esprit* was the highest achievement and *les bons mots* rattled up against the low glass roof, but never did a sharp vigorous thought break through to let in the fresh air.

I wanted to return to the freedom of Capri, which still seemed to me my proper home. But somehow I

remained fixed like a prisoner, angry, impatient, and only marking time as it seemed, yet, perforce, all the while helping to form the irrevocable life pattern with its inconsistent upward and downward lines.

RENÉE VIVIEN

It was unfortunate that Renée Vivien crossed my path at that very moment, and when her own life was at its lowest ebb.

She had long since broken away from all social ties, but of her exile she had made a lieu more desolate than can be imagined. I was taken by a friend to her flat, a rez-de-chaussée on the avenue du Bois.

There comes before me the dark, heavily curtained room, overreaching itself in lugubrious effects: grim life-size Oriental figures sitting propped up on chairs, phosphorescent Buddhas glowing dimly in the folds of black draperies. The air is heavy with perfumed incense. A curtain draws aside and Renée Vivien stands before us attired in Louis XVI male costume. Her straight blond hair falls to her shoulders, her flower-like face is bent down; she does not lift it even to greet us. Though I know that she is a very gifted poetess it is difficult to detect other than a seemingly affected and childish personality. Besides, it is the claptrap of her surroundings that holds perforce the attention. We lunch seated on the floor, Oriental fashion, and scant food is served on an-

cient Damascus ware, cracked and stained. During the meal, Renée Vivien leaves us to bring in from the garden her pet frogs and a serpent which she twines round her wrist.

Everything in her flat shows a like desire to surprise: a tunnel-shaped Japanese bed lighted from within; carved doors with Oriental lattice windows defying privacy. What possible affinity is there between these ugly surroundings and the poetical images of our pale hostess? It is clear that the world of things does not hold for her its further significance.

Though this first visit was followed by many others, her melancholy childlike self amid such a show of affectation never ceased to embarrass me and to keep me silent. I dare say she thought me naturally so, but it seemed to make no difference in her liking for me, and being completely astray, I soon found myself drifting along with her.

As these recollections insist on importuning me now, she herself becomes more and more indistinct; her face undefined is bent over ... even as it was then and I wonder why. Later I knew that she had never freed herself from an early sorrow ... and she sought relief.

If ghosts were wont to visit and haunt me, she, pale life, visited and haunted death. She expresses this in her epitaph:

Voici la porte d'où je sors ...
O mes roses et mes épines!

Qu'importe l'autrefois? Je dors
En songeant aux choses divines ...

Voici donc mon âme ravie,
Car elle s'apaise et s'endort
Ayant pour l'amour de la Mort,
Pardonné ce crime: la Vie!

When she intimated that an old friend of hers was
jealous of me, I willingly believed her and made it the
pretext to end our friendship. But she had taken this in-
direct way hoping to attach me still further. Someone
came to intercede for her. She was now alone and would
I not go back? I could not go back—a few months after-
ward I heard that Renée Vivien was dead.

Her short life had been but an effort to reach this goal.
She had waved to me from afar, not that she wanted help,
but that she hoped that I might turn and join her.

UNE RÉPUTATION

Every period has its fashionable forms of persecution
and these are always changing like the shapes of our gar-
ments. Sometimes their origin can be traced to certain
individuals who aim at being the inquisitorial leaders of
the idle and stupid tribe called society.

Before the world's war it was the fashion in Paris and
probably elsewhere to do for an enemy by giving him

or her what was called *une réputation*, the term being substituted by a sly look which sufficed to designate its special meaning. This had a tremendous vogue and in certain cases it harmed the helpless victim no less than did the bombs and poisonous gases that were to come with the war.

After the war the vogue was to label with some awful disease an enemy or even a friend, this last adding greater zest to that particular form of malice.

"Ah ce pauvre cher ami, il est pourri!" exclaimed a hostess within my hearing when the door had closed on a friend.

At the time I was seeing Renée Vivien it was the mode to show malicious concern about one's neighbor's reputation. My friendship for my former American friend and for Renée Vivien gave me just such a reputation. Someone had spied at my door the well-known carriage bearing the family crest of Renée Vivien's friend who, it seemed, had even something more than a *réputation*.

This soon got about, and recriminations came to me from all sides. As I was living in Paris solely because I wished to work in an art center, all this prattle seemed to me positively idiotic. What had it to do with me? "Mais vous êtes une femme du monde," retorted someone. "Une femme du monde" indeed! I vowed at that moment to seize whatever occasion might come my way to show what I thought about this reputation business. I will give them something to talk about, something to shock them thoroughly one way or the other. Now in

time, this is what I actually achieved and with no particular effort on my part.

GABRIELE D'ANNUNZIO

It was shortly before my exhibition that I was invited by Cappiello, the Italian artist, to a luncheon given for Gabriele d'Annunzio. There had always been much gossip about d'Annunzio's private life and now, on his arrival in Paris, his true personality was all but eclipsed by his notorious reputation. Stoned out of his own country he was to face even more stoning in Paris.

"Quelle honte qu'on n'a pas reçu avec honneurs ce grand homme!" exclaimed Comte Robert de Montesquiou, who was then his great admirer and later to become his friend.

To me he represented the great *lapidé* of our times. I did not know then, nor in fact have I ever known, the precise nature of d'Annunzio's misdeeds. Was it his disabused though fervent attitude toward women? Was it his debts? Or perhaps Eleanora Duse's tears which, while adding to her popularity, had by their theatrical appeal detracted somewhat from his.

But as I have already said it was a moment when people were particularly inclined to attack one another, so d'Annunzio's every foible was used against him. He was abused by all those who could be heard only through their concerted baaing.

It was with no little curiosity that I assisted at the luncheon given for this great writer.

We were seated at the same side of the table, so whenever it was possible I leaned back in my chair to observe him. D'Annunzio's face showed the smooth paleness of a scholar; it remained pale even when animated. He was inclined to withdraw to himself. Perhaps in order to correct this absence of mind, every now and then he would take from his waistcoat pocket a monocle. After adjusting it to his eye, he looked intently at everyone about him and then quickly put it back into his pocket again. This call to attention never occupied more than a few seconds.

He struck me as belonging to some other epoque, even to another atmosphere. His energy was revealed in every gesture he made. When he handled his knife and fork these became weapons rather than implements.

On being asked if he wanted more of some dish his "No!" was so emphatic that it shook his whole body.

There was nothing of the hothouse about d'Annunzio.

I was to know that his was a force of nature allied to, but also often at war with, a super-mental force.

When he addressed women his smile was entrancing, but then at once the corners of his mouth drew down to form what I termed *le pli amer*. Never was there a more bitter and crucified expression.

After luncheon our host showed his highly colored posters which were much appreciated in Paris. Now I

often wonder if d'Annunzio and I should ever have become such great friends if at that precise moment he had not leaned over to me and whispered confidentially, "And to think how much can be expressed without any color at all." Surprised, I answer that if he were really of that opinion perhaps he would like to see my work, which was almost without color. He had never heard of me or my work before. To him I was merely a young *femme du monde* possessing not even the voluptuous type he fancied. An expression of doubt and amusement crossed his face but, courteously, he professed interest and named a day to come to my studio.

I had read many of d'Annunzio's books, but it was only with an artist's understanding that my brain could follow the convolutions of those fever-stricken masochistic lovers who seemed to me to live in some peculiar sphere of their own. *La Città Morta* was my favorite. I had read it several times but I never wanted to see it played. Perhaps I feared that the popular and over-stressed actresses of those times might lack the intuitive sense to know just when to stop, just when not to overstep the limits. To me it was a miracle that such emotional intensity could be expressed without ever touching the ridiculous. I think that the secret lay in what is not generally known: d'Annunzio had a great sense of humor. Not that he used it in any of his works, nor felt it when working, but it was there *quant même* and helped to keep the balance even.

On the afternoon that d'Annunzio had chosen to visit me I surveyed my paintings and wondered why I had ever

wanted to show them to him. Of those melancholy and life-denying creatures was there a single one that could have played even a minor role in the great love dramas of the world? The idea amused me enough to help prepare for what was probably to be the evasive though polite attitude of my illustrious visitor.

But I was wrong. When he entered the studio, d'Annunzio, paying scant attention to me, went straight up to my pictures and after contemplating them he began improvising aloud a *dédicace* to each in turn.

I was to know that d'Annunzio was tuned to all moods for he contained them all.

Some years later he wrote "La Contemplation de la mort," and where is the d'Annunzio of *Il Fuoco* in such revelatory depths as these:

O ma vie, o ma mort,
 Où es-tu? où sommes-nous?
Nous sommes dans le lieu profond
 et la lampe de l'attente brule à terre:
 et la pierre est scellées sur nous,
 cimentée, renforcée
 avec des barres de for ...

And so began my great friendship and admiration for Gabriele d'Annunzio. He changed the world about me and lifted me from a state of deep despondency. His enthusiasm, his hero worship, his erudition and love for the English poets; his complete detachment from

all petty prejudices, scandals, and gossip. I never heard him speak maliciously of anyone, and he would take me to task if I ever happened to make any such lapse. In reference to this I remember our discussing the Titanic disaster. I mentioned a woman who, it was said, had managed to escape in an all but empty boat after having persuaded the boatman to row quickly away from the sinking ship. "What a coward!" I exclaimed, echoing the general verdict. "Ma che!" retorted d'Annunzio, "How can she be courageous if she is born timid? How can you judge her if you don't know her?" This instance came back to me during the war when d'Annunzio's own courage was put to so great a test and with what winged heroism he responded.

D'Annunzio allowed nothing that he felt keenly or perceived sharply to escape him. He must needs mold all to some form. To tell him not to touch upon this or that subject which interested him was like warning the winds to be careful where they blew. His writings were made up of material so inextricably part of his own sensibilities that whosoever lacked in understanding or demanded over-much of him were bound to be exposed in this the artist's exclusive domain.

I wished to know his point of view on what one heard about his legendary treatment of La Duse. He met my questions with a rush. What other woman had benefited so much from knowing him as she? Had he not helped her to become a great actress and provided her with the leitmotif of her life? Who could gainsay it? There was

also much about *la camera oscura* (the photographer's darkroom) where she would retire to open and read his private letters, he declared.

He had read aloud to her from the manuscript of *Il Fuoco* and *come una grand artista* had expressed for it unreserved admiration. Never once did she ask him to change any part of the book before publication. D'Annunzio's sincerity was indubitable. But La Duse held those hysterical Anglo-Saxon audiences that seek relief from habitual restraint in indulging in veritable saturnalias of stage worship. Art and the artist have no place among these pathological crowds. The play, however great it may be, is relegated to the shadowy background, while limelights follow the poses and affectations of the stage idols of the moment, going even so far as to cast glamor over their private lives. To these crowds La Duse was a superwoman with her sorrows and her tears; not the frustrated actress who would grasp tightly what by its very nature could be held in no way.

D'Annunzio seemed to be always pursuing or running away from some mistress or other. There was no reposeful intermediate stage. He was vain and showed a certain *mauvais goût* in his braggadocio, belonging as it did to a more rococo period.

When I took him to task for what seemed to me a lack of discrimination, he would reply, "Ma! Io appartengo al mondo intero!" (Why! I belong to the whole world!) I was to know, however, that he was far more judicious in his choice than he had liked me to believe. Yet it was

disconcerting when to describe a certain mistress he would give her a poetical name and then when one met *la bella Cigna Nera* to find that she had nothing more distinctive than a long neck.

When I first knew d'Annunzio there was, however, an exceedingly beautiful woman in love with him. She was the goddess type, tall and blond. Her passion for him was such that she emulated successfully the tortured heroines of his books. He was very attracted to her, but at the same time, like a little demon, he delighted in torturing this ever-sobbing woman. At the hotel where d'Annunzio was staying it was said that she would wait endlessly outside his door and at times that she even slept on the doormat, though this of course is hard to vouch for.

I had the occasion of meeting her. We were a group of d'Annunzio's friends assembled outside a church where we had gone to hear a famous organist play. Standing alone at a short distance away from the gay group was the tall blond woman and, irrelevant to the occasion, she was holding a handkerchief to her eyes and sobbing bitterly.

No one paid any attention to her and least of all d'Annunzio. Perhaps she was enjoying in some way this public demonstration of grief. I approached her and asked if there was anything I could do. Willingly she allowed me to lead her to my car and then to my house, where I bathed her swollen eyes with rose water.

She was a composite of vanity and humility; a beautiful statue whose emotional ego had been quickened by

a careless Pygmalion. Never would she forget my kindness, she said before leaving me. Yet it was this very Niobe who prevented my painting d'Annunzio's portrait the following summer.

ARCACHON

It was at Arcachon that I chose a villa where from across the silence of a motionless bay could be heard the distant roar of great waves beating on Cap Ferret's Atlantic shores.

I invited d'Annunzio to stay with me and to pose for his portrait. He accepted and seemed much relieved to escape from the many complications of his life in Paris.

Fortunately I did not begin at once to paint the portrait but limited myself to making sketches of his face (one of these, a profile, now belongs to Miss Radclyffe Hall). I suspected that he was not so free as he had liked me to believe, and my suspicions proved to be well founded. The Niobe, left behind in Paris, was now lamenting louder than ever. I heard she was leaving for Arcachon and that she carried a revolver.

D'Annunzio had just received from Italy several trunks full of clothes. He was overjoyed at seeing his things again. There were shoes, shirts, and waistcoats but still more important his pink hunting coat.

D'Annunzio had gone upstairs to put on this coat and was about to descend to show me how well it suited him,

when my chauffeur, Bird, burst into the room to tell me that a tall blond lady was outside, she was very agitated and demanded to see me. I had already given orders to let no one in without consulting me. What was he to do? he asked. My first impulse was to see her and to pacify even as I had already done ... then I remembered the revolver. To be killed by a Niobe and all because of a misunderstanding would be too ridiculous. I told Bird not to let her in, and left it to his own discretion what was best to do. In the midst of these perturbations down came d'Annunzio in full hunting regalia: pink coat, breeches, and boots. Hastily I explained what was going on in the garden, but he refused to listen. He had come down on purpose to be admired; nothing else mattered. To show himself off he began pirouetting about the room. My eyes followed him, and I even noticed that the stiff pleats of the pink coat stuck out in a funny way at the back.

Agitated voices could now be heard in the garden. D'Annunzio, exhausted by his efforts and perhaps paler than usual, flung himself upon a couch and remained there without offering any solution to the problem facing us.

Bird returned to announce that the lady had at last gone away but not before making desperate efforts to get in, and that he had been obliged to detach her hands from the bars when she tried to climb over the gate.

For a long while afterward d'Annunzio remained silent on the couch. I knew that his thoughts were now with his weeping friend—even as were mine.

He had drawn her into his own turbulence. She allured in so far as she was capable with just such stormy reflexes. With him, intellect could direct, but it could not change a fundamental need for violent and conflicting emotions.

My complexities were not of those elements. At that moment of rising whirlwinds I felt small and out of place. The following day I heard that d'Annunzio's friend was installed in a villa in the very heart of the Dunes. She was ill.

Decisions often come by way of a mysterious weight that inclines the scales for us. An urgent call to Paris. In the train back my hand caught between the coach doors. My hand in a sling kept me in Paris, I wrote.

I saw Montesquiou and he was much perturbed by the accident. Sometime later when I told him that my hand had never been crushed at all, he refused to believe me.

THE PORTRAIT

It was during the following year at St.-Jean-de-Luz that I painted the portrait of d'Annunzio, which now belongs to the French government.

My villa had a view extending far over the sea intersected by the long dark line of a breakwater. Huge waves dashed against this barrier and leaped high into foaming pinnacles in the air. What better symbol could there be for the portrait.

D'Annunzio thoroughly disliked posing, but, nevertheless, every morning at the exact time agreed upon, he would stand before me like a soldier at his post, his face expressing grim determination. Happily this expression would change during the work.

The painter in his selection of the many characteristics which mark his sitter must needs reveal himself.

I saw d'Annunzio as a *lapidé*, an exiled poet and, paradoxically, one who could seek with the same unholy vigor the superman, the demon, or the lonely saint within him.

He had never thought to be painted in this deeper sense and at first he rebelled. "I can accept the mouth but not the eyes!" he exclaimed when he feared I was about to give to these the same anguished expression as I had given to the mouth. In point of fact I painted him exactly as had been my intention from the first.

The Niobe seemed to have disappeared, or perhaps she was standing aside while I painted the portrait. My villa was, however, bombarded with love letters from all directions and some of these d'Annunzio would read aloud to me. So many women were injured by the demoniacal side to his character but I well understood the sheer delight he took in playing with his element fire. Past trials had wrought for me an armor of the hardest metal so, though very much attracted by his personality, I remained immune. His fire could warm, but it could not burn. His understanding of this is clearly expressed in a poem he wrote on the portrait I had painted of myself.

On one occasion, when looking at the photographs of his women friends that covered the walls of one of his rooms, I asked him why there was no photograph of me. He answered, articulating sharply each syllable as was his way of pronouncing French, "Ma! Vous n'êtes pas une femme!" I was never quite sure whether this implied approbation or disapprobation. Probably both, for though he was attracted by women, he was, at times, no less repelled by them and consistent with his other ascetic side he would then inveigh against the very excesses he himself had provoked.

To know d'Annunzio was to know his kindness expressed in many ways. He always expected simple minds to rise with him to higher level than was theirs. He never talked down to them. Perhaps this is the secret of his success as a popular orator. It certainly appealed to the Italian people who are naturally lyrical; but even those who served him outside his own country felt drawn by the magic of an eloquence they could not understand.

The zeal of his servants was such that they would jostle one another as they rushed upstairs to answer his bell, each wanting to be first.

There was a row of small birdcages on the windowsill of his sitting room. I asked why he did not put all the birds into one big cage. "No! It would not do at all," he answered. "The bird in that cage belongs to Aelie, the maid; the other one to the houseboy, and the third to the cook. They want me to show interest in each of their birds separately."

But in love affairs d'Annunzio showed a very different personality. He was then the diver who must plunge to dangerous depths; but despite himself, and, consistent with another disposal, he is time and again flung back unharmed.

But are there not always two who make these plunges together? I am asked. Does he not at times reappear at the surface alone? That may be, but partners are never lacking to play games of chance; all those who would seek the exhilaration of just such perilous doings.

Friendship has always seemed to me the ultimate goal, though it may need wings to attain it.

It was precisely my friendship for d'Annunzio which allowed me to understand and delight in the many aspects of his personality. He was amoral and disarmingly childlike, making innocent his every extravagance. His sense of humor coincided with mine and we were always ready to laugh. But in order to uphold his more tragic sense he would say, "On ne rit pas de l'amour." If he appreciated humor in its pure sense, he despised what he called *l'esprit gaulois* and he rebuked me whenever I indulged in that form of mockery. Being neither effete nor effeminate he contained no malice, no petty meanness of any kind. The Nietzschean doctrine of the Superman was his by right of his super-mental and physical vitality. If the title of this book, "No Pleasant Memories," is not pertinent to certain periods of my life it is because those periods no longer belong to memory alone, they now form an integral part of the present.

When d'Annunzio's portrait was finished I brought it back to Paris and invited "tout Paris" to see it. D'Annunzio decided not to be present at the show but to come in afterward to hear about it.

As I had expected there was much surprise and adverse criticism. Certain exclamations and remarks went to show how far I had stepped beyond the limits of conventional portrait painting.

"Does he know that you have painted him?" whispered one excited lady who evidently saw the portrait as some awful form of vengeance.

"His mouth is like the crater of a volcano," said someone else.

Afterward d'Annunzio was extremely amused. We laughed so much over the comments that I doubt whether anyone seeing us for the first time would have believed that he inspired the anguished expression on the portrait or that I had painted it.

MUSÉE DU LUXEMBOURG

The director of the Luxembourg Museum asked to see the portrait of d'Annunzio. I was fully aware that, apart from the cosmopolitan set in Paris, among whom I happened to be, there was a highly intellectual France with an understanding and appreciation of art like no other country in the world. However, I feared that my portrait might prove too unconventional for official approval.

But I was mistaken. Monsieur Léonce Bénédite, the conservateur du Musée du Luxembourg, was a courageous forerunner of just such paintings that had still to be recognized. It was even said that he hid certain pictures until his less enterprising colleagues should adopt his more advanced views.

Monsieur Léonce Bénédite remains in my memory as I first saw him in his private rooms at the Luxembourg Museum. He was surrounded by a minor collection of works of art and on his table I remember a small weeping figure by Marie Bashkirtseff. His head, with its finely molded features, gray hair, and pointed beard, resembled a portrait of an old master. Incidentally it was probably this resemblance which had prevented my meeting his desire to be painted. Like Montesquiou, he was crystallized to some over-recognized type. He had an old-time courtesy together with an up-to-date quickness of observation. He frankly admitted to me that when he first saw d'Annunzio's portrait it gave him a shock. At first I envied him the apparently peaceful world in which he lived entirely devoted to art, but later I heard that he was constantly assailed from all sides and his life was anything but peaceful.

IDA RUBINSTEIN

D'Annunzio was writing a play for Ida Rubinstein. He was able to judge of her ability as an actress solely by the way

she mimed the role of Cléopatra in Diaghilev's ballet. But d'Annunzio, perspicacious and ever ready for any venture, found in this femme fatale, with whom he was already much in love, the inspiration for his Saint Sebastian.

Whether she had sufficient voice for such a role came only as an afterthought. Fortunately her voice proved excellent and now nothing seemed lacking ... except, perhaps, that Ida Rubinstein did not or rather could not return d'Annunzio's affection.

Ida Rubinstein proved to be no less a miracle than was the Miracle of Saint Sebastian. Though she possessed little stage experience, her *élan* and the aspiring quality of her acting balanced such weighty forces as were contained in the art of Gabriele d'Annunzio, of Claude Debussy, and of Léon Bakst. The intense masochistic emotions of d'Annunzio, his waves of lyricism and depths of medieval lore; Bakst's crowded Barbario splendors seeming barely to part, to make way for the aureoled saint; Debussy's music in ever-rising momentum and, even as the sacred arrow, disdaining the return to earth, to human dissidence.

It was after the first performance that I met Ida Rubinstein. She was seated curved over as if the wings of martyrdom had carried away their triumph to leave but an aftermath of prostration. Her lifted eyes had disappeared under their lids and she could barely bring them down to greet us.

It was Ida Rubinstein's elusive quality that fascinated. She expressed an inner self that had no particular

denomination. Her beauty belonged to those mental images that demand manifestation, and whatever period she represented she became its image.

She was Russian of Dostoyevsky tendency but without the heavy inconclusiveness of the Russians; she was Jewish, an exquisite achievement of that ancient race. Her father was Jewish and her mother a gypsy, so she told me. In reality she was the crystallization of a poet's image, a painter's vision, and as such she possessed further significance. I remember Robert de Montesquiou, who was her fervent admirer, endeavoring to impress upon me the wonder of her allure when he met her for the first time. Enthusiastically he described her manner, her gesture, and then led up to the great moment when addressing him she said, "Monsieur, asseyez-vous."

To him this was no anticlimax. He was experiencing over again, in imagination, just that other quality which gave distinction to everything she said or did.

She seemed to me more beautiful when off the stage; like some heraldic bird delicately knit together by the finest of bone structure giving flexibility to curveless lines. The clothes she wore were no longer modes, for without effort everything contributed to making her seem like an apparition. The banality of her surroundings, to which she paid no attention, made the effect even more striking.

I remember one cold snowy morning walking with her around the Longchamps racecourse. Everything was white and Ida wore a long ermine coat. It was open and exposed the frail bare chest and slender neck

which emerged from a white feathery garment. Her face sharply out with long golden eyes and a delicate bird-like nose; her partly veiled head with dark hair moving gracefully from the temples as though the wind were smoothing it back.

When she first came to Paris she possessed what is now so rarely spoken of—mystery. Hers was a mask whose outer glow emanated from a disturbed inner depth. Someone asked me if she had an inner life. My answer was, "Yes, but a very uncomfortable one."

She was cultivated in so far as it suited her. She knew by heart pages of Goethe and Nietzsche and would declare Dostoyevsky to be greater than Shakespeare, making her point open to discussion.

But it was her intuitive sense, her star as it were, which had she followed, would have guided her into realms of her own. Her form of expression required no schooling, so when she adopted as monitor the popular and over-stressed actress Sarah Bernhardt I felt very strongly about this lack of self-comprehension. Yet I never succeeded in enforcing my views upon her. She stood by her decision to labor at what she had merely aspired toward. It was Pegasus demanding to be hitched to the plow.

Ida was much concerned about the proper pitch of her voice; should it be low? From *La Princesse Lointaine* she would recite verses in both ways. I chose the lower one more to show interest than to express an opinion, which seemed uncalled for. She told me later that Sarah Bernhardt had preferred the higher pitch.

It was the same with her dancing. Her movements should have been improvised for they were naturally expressive. But, no, she must needs to go through the intensive training of an ordinary ballet dancer and for this she called in a celebrated dancing teacher.

There comes before me the picture of this goddess clad in a tutu, with long slender legs, jumping and pirouetting to mean measures tapped on the piano. The dancing teacher, unable to recognize divinity when it came her way, was not pleased at all and mid the noise of the music she would come up to tell me about a younger and *plus petite* pupil who, she affirmed, was a veritable prima ballerina.

It was her gift for impersonating the spirit of beauty of every epoque that marked Ida Rubinstein as unique. She enhanced even that 1880 sob stuff *La Dame aux Camélias*. She was an inimitable Nastasya in Dostoyevsky's *L'Idiot*. And who other than she could have played *La Pisanella*? I remember her in Verhaeren's *Hélène de Sparte* without remembering anything else of the play bearing that name. She could have brought the art of miming to new and transcendent heights.

My portrait is of Ida Rubinstein as she appeared when walking swiftly through the wooded parts of the Bois de Boulogne. An apparition in black flowing cloak with sharp lights on its white satin revers.

I am glad to have known those prewar days before the dust storm of Russia had reached us and all but obliterated what remains of individual beauty in the world. At

present we are surfeited with mass displays of all but naked beach girls. And those other stereotyped beauties, mere puppets in the hands of cinema industrialists, who in certain unevolved countries manage to limit and make commonplace their every interpretation.

Ida posed for me very badly indeed, so of the many portraits I would have liked to paint of her only this one exists. I even doubt whether she would have posed for me at all had not my studio been somewhat unusual. Evidently she found some affinity with the long glass-covered terrace, its masses of white flowers and black and crystal decorations. When posing she was either in a state of exaltation or plunged into the depths of despair. Once when in this last state she expressed the opinion that there could be no more beautiful place in the world than my terrace wherein to commit suicide. It always surprised me that my surroundings should strike others as peculiar. When Robert de Montesquiou came to read me a *dédicace* he had written for d'Annunzio, I took him up to my terrace for the first time. Once there, instead of reading from the roll he held in his hand, he put it back into his pocket and then walked up and down silently looking about him. Afterward he told someone he was so impressed by his surroundings that he had been unable to read the *dédicace* brought expressly for that purpose.

There was also the workman called in to do some work on this terrace. He turned to my maid and in a hushed whisper asked: "Est-ce qu'il y a quelqu'un de mort dans la famille?" Yet several years later when I was moving

from this house, there was found hidden in a small room adjoining the terrace an array of empty whisky and soda-water bottles. This went to show that some members of my household (probably the English chauffeur and the maid) had enjoyed viewing Paris together from a terrace that was somewhat like a catafalque.

ENEMIES

If I made no friends in the worldly circle from which I was detaching myself I certainly did make enemies. It was at that moment that a particularly vile form of vindictiveness, of which I have already written, began to mature and, strange as it may seem to those whose anger dissolves even long before the allotted hour of sunset, this offensive never hung fire during some twenty-five years, that is to say, up to the present time. Surely such persistence was worthy of more definite results: I seemed so easy to attack being alone and only too ready to demolish all those barriers of defense set up by worldly approval. But who can hope to attack effectively what indifference has made invincible.

It was my good fortune to have gained complete freedom of spirit, and this not so much through my art, which is ever ready to disturb, as through a still more precious love of books and study. No circumstance could trouble the joy and peace found in this inner seclusion. To my mind it is life's most selective gift.

I was traveling in Switzerland with Ida Rubinstein when war was declared. Reluctantly my mind returns to those four years of intense mental strain and to the many incidents that were or were not relevant to those tragic times.

On our way back to Paris, Ida was very agitated. She spoke of her future, her career. She had passed the night on her knees praying God to avert this calamity, she said. I remember being more indignant than anything else. How was it possible that presumptuous man failed again and again to avert these mass suicides, which Nature thrusts upon him periodically. Surely it was no mere question between angry nations but of Nature adjusting man's mistakes. My philosophizing over birth control brought no response from Ida, who was lost in the tragedy of the moment.

As I was strongly against the war, on returning to Paris, I set myself to working hard at my painting; but of course this attitude proved impossible to keep up and soon along with everyone else I was doing all I could to help. My efforts were more especially directed toward the French artists, and one of my most precious belongings is a small bronze plaque especially engraved which they presented to me. Indirectly because of the war my income from America had stopped, so I sold some personal valuables in order to present a small donation to be named after a fallen artist-soldier. The proceeds of this fund were eventually given to the blind soldier

Lemordant. I wanted to join a unit at the front and tried to harden myself by driving an open car during an unusually cold spell. This effort sent me to bed with pains in my back and later to Aix-les-Bains for a treatment.

I can see myself seated in the black and crystal terrace watching the Zeppelins as they direct their course toward the Eiffel Tower; the terrific bombing reminding me that it is no mere play.

It came to me as a surprise that not one of my servants was French. They all began to hate each other thoroughly and to fight among themselves. I feared them more than a whole battalion of German soldiers. My cockney chauffer and my Alsatian maid were particularly hostile. She confided to me that when her German brother, whom she loved, entered Paris with his regiment she would run out into the street and embrace him even though her husband was a Frenchman. The Spanish concierge could now only speak in her own language. The overpolite Belgian chef apparently hated them all alike—allies included, and while bowing to me over and over again, as he backed out of the room, he hurled imprecations upon all the personnel of the household.

I inaugurated with my friend Natalie Barney my newly whitewashed cellar. Bird, the cockney chauffer seated nearby, was armed with a pickaxe, "To dig you out, M'm," he explained. Then when terrific thuds of bombing shook the very ground, to reassure he would invariably say, "Barrage, M'm!"

I was in my bathtub when the first Big Bertha fell. It

was evident that some new terror was upon us. After dressing quickly I left the house to keep a luncheon appointment, but it was too early so I ventured my way toward the Trocadéro Gardens opposite. There a few people were silently walking about as if in a dream. All was in suspense and to catch an eye was to reciprocate a look of apprehensive inquiry.

On reaching the restaurant I was directed to a table in the rear, as far as possible from the large glass windows. One of our friends was missing; so after luncheon we went to seek her at her flat. No one answered the bell, and as we stood waiting in the courtyard undecided what to do, a door leading into the cellar opened and there stood before us a strange figure. It was clad in an old gray wrapper with bedroom slippers, hair covered with cobwebs, and a rusty lantern dangling from a string tied round the neck. One hand gripped a valise and the other a timetable. We recognized our friend. On hearing the Big Bertha she had retreated to the cellar along with everyone else from the building. It certainly was no time for mirth yet we all laughed just the same.

SUR UNE IMAGE DE LA FRANCE CROISÉE, PEINTE PAR ROMAINE BROOKS

D'Annunzio was leaving Paris to make his famous speech at the Quarto near Genoa. Before his departure he came to read it aloud to me.

On the same afternoon an old acquaintance of mine, A. de G., had called to express his appreciation of my painting of a Red Cross nurse symbolizing France at war, which was being exhibited in Bernheim's window on the Boulevards. This picture inspired d'Annunzio's "La France croisée," one of his rare French poems. This poem, written on folio sheets in his characteristic and forcible handwriting, was shown as major interest along with my picture.

VENICE

News came that airplanes were bombing Venice. I decided to visit it once more before it should be too late.

Had I known what suspicion a woman traveling alone in those war days would arouse perhaps I might never have started. As it was I arrived in Venice and went to the Hotel Danieli. The bombing began the very next morning. The sound of a ship's siren drew me to the window. In the streets people were looking up at the airplanes as they ran for shelter. In my room from between double doors leading into the corridor, lamentations arose. It was my frightened maid who had wedged herself in between the leather padded panels and for a long while she refused to leave this shelter.

At the hotel everyone came in for a certain amount of suspicion. In the dining room there was a titled and elderly couple who occupied a table not far from mine.

One day they failed to appear. On inquiring about them I was told that they had left the lights on in their bedroom, so in the middle of the night they had been hustled off to prison. "They are spies," exclaimed everyone. The rules concerning lights were very stringent. When a match was struck in the street even its tiny flicker was carefully shrouded. During the night I could hear people falling into the canal. A splash, a shout, and then cries, growing fainter and fainter. The first time this occurred I rushed to the bell and rang furiously; but no one answered it. Next morning the waiter informed me that as there were no lights, drunkards were apt to fall into the canals; but, he added to reassure me, they are always pulled out of the water in time.

In the early spring, Venice can be very damp and cold. My room was unheated so even in the daytime while reading I would lie in bed under a red eiderdown in order to keep warm. Books on the Risorgimento particularly interested me. Had not d'Annunzio in his speech and attitude some of the sweep and scope of these great patriots?

Every day I fed the hungry pigeons in the piazza, but the beggars crowding round seemed so envious of the bread brought from the hotel that I found myself giving out coins to an ever-growing crowd by way of propitiation.

Were it not that the war made one fear closed palaces and darkened canals should awaken only to face destruction, Venice had seemed of even greater loveliness than before. A loveliness all crumpled up by centuries and

now awaiting its fate with closed eyes. The black lines of people streaming ant-like over its bridge and through its narrow streets belong to a life apart, seeming of no importance.

I was asked by a Paris acquaintance to remember her to Lord X who was staying at the Hotel Danieli. Lord X (his name eludes me) was big, fat, and boyish-looking. He was on some important mission, and an elderly military escort always accompanied him. Lord X was very pleased to meet me, but his escort decided at once that I was no other than a dangerous spy whom he intended to trip up if he could. Never once did he allow Lord X to go out alone with me, and at the café where we often sat and drank coffee, he would lean over the marble table and listen intently to every word I said. Lord X was tired of him and told me as much, and at times he even snapped back at his over-attentive escort. The situation at first amusing soon became embarrassing. When Lord X informed me that every morning he went to the Lido to test bombs and I—merely to show interest—spoke of getting up early enough to see them from my window, the escort fairly boiled over with excitement. Here at last was evidence to justify his suspicion.

It was the very next morning while we were lunching together at the hotel that a messenger handed me a letter from the governor of Venice. "Hah! You will soon be leaving us now," exclaimed the exultant escort. I opened the letter to read a few courteous lines expressing appreciation of "La France croisée" (one of the pamphlets of

d'Annunzio's poems and my picture edited for the benefit of the Red Cross), and there was also permission for me to remain in Venice as long as I desired.

Passing this note to my acquaintances I was much amused by the discomfiture which one of them was clearly showing.

PORTRAIT OF "IL COMMANDANTE"

D'Annunzio was now in Venice with his military unit. In his new role of Commandante he had gained in stature and energetic allure. I admired his uniform: the black cloth and astrakhan-edged dolman over which fell the heavy pleats of a blue-gray military cloak. I decided to paint another portrait of him in his new role.

Every morning a gondola would take me to a studio which d'Annunzio found for me in the Zattere. But I could never give full force to painting that portrait; it advanced too slowly. D'Annunzio was able to pose only at rare intervals when his military duties permitted.

D'Annunzio was then living in the smallest palazzo of the Grand Canal, a sort of eighteenth-century *bonbonnière* filled with bibelots. There was a collection of clocks, every one of which d'Annunzio had set going and the tiny drawing room was filled with the sounds of their discordant tickings. This palazzino was heated by gas and one could smell the fumes even outside along the narrow streets.

D'Annunzio liked to be very warm and his rooms were kept so hot that the wax candles drooped in their bibelot candlesticks; others melted and ran up against the ornate mirrors. Inside the house the smell of gas was overwhelming. While waiting downstairs I would open wide the window and then quickly close it before my host entered the room muffled up in the warmest of woolen sweaters.

This picture, however, fails to coincide with another one: d'Annunzio at the front with his soldiers. There he feels neither heat nor cold; he is oblivious of danger, even of death. But d'Annunzio's dual personality delighted in confusing these antithetical aspects.

One morning when d'Annunzio was posing in my studio, news was brought to him that his great friend Miraglia had just been killed when his airplane fell into the Lagoon. This tragedy hit d'Annunzio very hard and I doubt if he ever got over it.

Before this accident occurred, d'Annunzio would occasionally take his friends out in his gondola to visit some interesting aspect of Venice. One late afternoon I found myself with a few others including Lord X (but not his escort) on just such a tour. After gliding through many narrow canals, we landed at a remote calle. D'Annunzio then led us to an old crumbling palazzo and looking up at a window he called out a name twice over. Slowly the heavy door opened and before us in the dark entrance stood a luminous figure whose long blond hair fell to the ground, edging her white garment like a golden

aura. I heard d'Annunzio bidding this apparition to sing; thereupon a thin voice rose high into the air, converting metallic sound into melody. Even when the singing ceased we remained silently impressed. Now what broke the spell at that psychological moment is hard to say. Did someone ask Lord X to sing too or was he inspired to do so of his own accord? However that may be, he suddenly stepped forward, folded his arms on his chest, and then in a loud voice burst into the strains of "It's a Long, Long Way to Tipperary." He sang the song twice over and we were all brought back to earth and to the war. What the apparition thought of Tipperary will never be known. At the end of the song she smiled, saluted us, and then faded away into the dark of the old palace.

Afterward d'Annunzio showed unusual reticence when questioned about this visit.

I knew that d'Annunzio was pleased with his portrait. I would often find him seated alone in my studio looking at it. I painted him against the green and deep blue of the Adriatic. An airplane cuts its way through the water, leaving jagged white tracks in its wake. Could there be a more appropriate symbol: action urging onward in search of freedom in an ever-receding skyline, as opposed to the other portrait: rebellion dashing upward to escape barrier walls. A year later I sent this portrait to d'Annunzio at his request, and for a long time afterward he would write to tell me of the large hall he was constructing where the portrait was to hang in a place of honor among his other war trophies.

Except for war work I was now living in Paris in seclusion and completely detached from all former acquaintances. It was a relief to be once again adrift and alone. I thought that like myself everyone was occupied with the war. It seemed incredible that the same revilers could still be about and as active as ever; that the absent were no less spared than were those who disdained retaliation; but such was the fact. I intended to retire to some more pleasant solitude after the war, and in the meanwhile to keep a distance between me and the hornets' nest of foreigners in Paris whose unfriendly interest it had been my bad luck to arouse.

But what is the use of mapping out plans beforehand, seeing that the future must conform to the many outside patterns that are constantly reshaping its borderlines.

Friendship came to me again bringing its compensations but also demanding its toll.

Old Lady Anglesey wrote that she wanted to see me. She was like a bibelot. There was no malice in the thin clatter of her porcelain composite. I went to her flat and there I met Natalie Barney. Now everyone in Paris knew of Natalie Barney. Her spirit, her writings in the form of *pensées*, and her poetry. But as usual it was her reputation rather than her gifts that was commented upon.

One afternoon before the war for some unknown reason I accompanied Aunt Minnie to a reception given by an American society woman of the pouter pigeon variety.

There were many of these pigeons, all looking very much alike, and they were assembled to drink tea, eat cakes, and play cards. One of these was talking to Aunt Minnie when my attention was attracted by hearing her mention Natalie Barney's name. "She will be received again in society when she returns to her mother's friends," I heard. Looking round at these smug and puffed-out members of society I decided that Natalie Barney had doubtless made more inspiring friends elsewhere.

Now by way of digression I must add that when some years later I met Natalie's mother she proved to be the most delightful, unaffected, and tolerant lady possible. The natural elegance of her manner and, above all, the charm of her smile will always remain vivid in my memory.

Renée Vivien had often spoken to me of Natalie Barney and I found little interest in listening to those endless love grievances which are so often devoid of any logical justification.

Before I knew Natalie I often caught glimpses of her from my car solemnly walking in the Bois de Boulogne followed by a pretty but insignificant little woman dressed in Oriental clothes with a shawl on her head. This left me wondering till I knew and understood Natalie. She possessed, along with many other literary people, the capacity of endowing the commonplace with her own poetical fancies. She told me that when this little woman danced (and very second-rate dancing it was) it brought to her all the splendors of the East. It was the

same at another time with a Chinese girl. This young person who looked Chinese, except for a long nose, had been educated in Belgium and during the process lost all the natural reticence and dignity of her race to become like some over-free and crude Westerner. But Natalie would thrust a sword into her hands and tell her to jump about in Chinese fashion and that sufficed to create the illusion.

Natalie herself was a miracle. Though she had lived many years in dank, unhealthy houses, among many dank, unhealthy people, she remained uncontaminated, as fresh as a spring morning. The finer qualities of her intellect had allowed her to rise above rather than remain within her chose milieu. Her *esprit* was used neither as a weapon of defense nor of attack, but rather as a game wherein she found few opponents worthy of her subtle repartee. She never ruffled anyone. To be *spirituelle* without malice, to keep well within two ruled lines is an achievement. Her rebellion against conventions was not combative as was mine. She simply wanted to follow her own inclinations—these not always bringing credit to her. In those days, bohemia was the only refuge for the independent, and when I first knew Natalie she was certainly one of its members. But later, after the war, when points of view had broadened, she actually became popular and this was a sore disappointment to me. It was not long before I was again meeting at her house the very hornets I had hope to escape forever. But I had never found a real woman friend before and Natalie

brought me a wealth of friendship which I gratefully accepted and fully returned. After all, I reflected, the point is not whether she is popular but that I remain firm in my contempt of popularity. So when in spite of myself I was dragged into her milieu, I soon became like one of those caterpillars we read about which when captured is paralyzed in such fashion as to allow its enemies to devour it alive and at leisure. In such wise friendship she held me prisoner. I could say little about this peculiar situation to Natalie, for she soared above any such petty vindictiveness, and besides, she was apt to ignore what did not touch her directly. It took some twenty years before she realized that I had not been all along mildly afflicted with some form of persecution mania.

I must need connect those former days with the present if I am to relate how my friend Natalie was finally convinced.

Not long ago I went to New York to paint a portrait. After finishing it I was resting quietly when a letter from Natalie informed me that an acquaintance of hers (one of the Paris hornets) was to visit America and that it was up to me to see her. Now Madame Unselle had many friends of her own kind in my country while I was practically alone. Do I not belong to those tribes which are more often than not stupidly prejudiced, divided in rivalry, and lacking totally in a sense of solidarity? But this hornet came from the beloved France so I emerged from my shell to greet her. The lady had decided beforehand the role she wanted me to take: a sort of lady companion

of her lecture tour which was to begin at once in Chicago. Now her way of speaking English was ridiculous and her culture, in the real sense of the word, nonexistent: she was out solely to make money and her friends had arranged that she should provide a sort of clownish chitchat for Middle West American audiences, who are ever ready to accept what is foreign. Her manners were those of a fidgety monkey who viewed people solely as possible trees to climb. No one had ever discouraged her absurd pretensions and she, lacking in native wit, could comprehend little that lay beyond her own limitations.

It was no pleasant experience when this little person, finally understanding that I had no intention of accompanying her to Chicago, began then and there and in public to revile me. She spitted out all the venom which up to then I had been receiving only in driblets from that particular group of enemies in Paris to which she undoubtedly belonged. After shouting about my private affairs, of which she could know nothing, she ended by calling me a liar in order to forestall any protest on my part. All this took place before an astonished group of acquaintances who happened to be present. "She has a sick brain," said someone, wishing to exonerate her. Astonished, but feeling no such virulence, I remained silent.

However, this uncomfortable moment went to prove my point which had gained weight with time and now triumphantly I could assume the what-did-I-tell-you attitude.

Even during that period of tension one was conscious that a new barbaric fighting world was detaching us from an old familiar world with aesthetic expressions that had reached their climax. Mutilating war was already setting up its own idols of distortion. I felt deeply this change and tried to express it. Who other than Ida Rubinstein with her fragile and androgynous beauty could suggest the passing away of familiar gods. My plan to paint her as a weeping Venus caused me great disappointment. At first Ida seemed willing enough to pose, but soon her keyed-up and erratic state of mind showed how useless would be any further efforts on my part to paint her. At the time I must have felt badly about this, for I remember being determined that my weeping Venus should resemble Ida in no way. But the resemblance was most persistent. Though I changed the features over and over again, yet the face remained that of Ida Rubinstein. This shows how deeply significant is that first impression. It fixes itself on the mind and any subsequent disposal of line and color must needs follow that inner direction.

It was of this picture that Natalie Barney wrote:

The Weeping Venus
(by Romaine)

Laid out as dead in moonlight shroud
Beneath a derelict of cloud:

A double wreckage safe from flight,
 High-caged as grief, in prisoned night—

And then more remotely:

 ... Too luminous the dreaming of the sleeper
 Whose tears are prophesies and second-sight.
 Has death no under-sea, no darkness deeper,
 In which to satiate our need of night?

It was surprising that Ida, whose vanity was great (a vanity which never surpassed her superlative beauty), should have shown such indifference about herself in many ways. In so far as I know during our three years of friendship she posed for no other portrait painter nor did she possess a serious portrait of herself, this of course from an artist's and not a worldly point of view. Bakst's colored drawings show her as subordinate to the general decorative scheme or as a chosen type of beauty completely lacking in psychological interest of any kind.

ROMAINE BROOKS (1874–1970) was an American painter most known for her muted color palette and deeply personal portraits. Among her sitters were the dancer Ida Rubinstein and the poet and novelist Natalie Barney. She spent most of her life in Paris and challenged conventional ideas of gender and sexuality, themes that carry over into her art. Brooks's career reached its height in 1925, when her work was exhibited in London, Paris, and New York. In the 1930s, Brooks began work on her memoir, "No Pleasant Memories," which consists of sketches of her troubled childhood, musings on artists' roles in society, and reflections on her own rejection of the norms and traditions of art. Largely forgotten by art history, Brooks bequeathed a number of her paintings to the Smithsonian American Art Museum, Washington, DC, where recent exhibitions have sparked a renewed interest in her work.

LAUREN O'NEILL-BUTLER is a New York–based writer whose book *Let's Have a Talk: Conversations with Women on Art and Culture* brings together nearly ninety interviews. A cofounder of the nonprofit magazine *November* and a former senior editor of *Artforum*, she has also contributed to *Aperture*, *Art Journal*, *Bookforum*, and *The New York Times*. Her essays have appeared in monographs on Maria Lassnig, Leilah Babirye, and Carrie Moyer, among other artists. In 2020, she received a Warhol Foundation Arts Writers Grant. She holds graduate degrees in art history and philosophy, and has been a visiting critic at Cooper Union, Stony Brook University, University of Southern California, Rutgers, Yale, and the University of Chicago. She is currently part-time faculty at Hunter College and The New School and has previously taught courses at the School of Visual Arts and the Rhode Island School of Design.

"Ekphrasis" is traditionally defined as the literary representation of a work of visual art. One of the oldest forms of writing, it originated in ancient Greece, where it referred to the practice and skill of presenting artworks through vivid, highly detailed accounts. Today, "ekphrasis" is more openly interpreted as one art form, whether it be writing, visual art, music, or film, that is used to define and describe another art form, in order to bring to an audience the experiential and visceral impact of the subject.

The *ekphrasis* series from David Zwirner Books is dedicated to publishing rare, out-of-print, and newly commissioned texts as accessible paperback volumes. It is part of David Zwirner Books's ongoing effort to publish new and surprising pieces of writing on visual culture.

OTHER TITLES IN THE *EKPHRASIS* SERIES

On Contemporary Art
César Aira

Something Close to Music
John Ashbery

The Salon of 1846
Charles Baudelaire

A Balthus Notebook
Guy Davenport

Ramblings of a Wannabe Painter
Paul Gauguin

*Thrust: A Spasmodic Pictorial
History of the Codpiece in Art*
Michael Glover

Visions and Ecstasies
H.D.

Kandinsky: Incarnating Beauty
Alexandre Kojève

Pissing Figures 1280–2014
Jean-Claude Lebensztejn

The Psychology of an Art Writer
Vernon Lee

Degas and His Model
Alice Michel

28 Paradises
Patrick Modiano and
Dominique Zehrfuss

Summoning Pearl Harbor
Alexander Nemerov

Chardin and Rembrandt
Marcel Proust

Letters to a Young Painter
Rainer Maria Rilke

The Cathedral Is Dying
Auguste Rodin

Giotto and His Works in Padua
John Ruskin

Duchamp's Last Day
Donald Shambroom

Dix Portraits
Gertrude Stein

Photography and Belief
David Levi Strauss

The Critic as Artist
Oscar Wilde

Oh, to Be a Painter!
Virginia Woolf

Two Cities
Cynthia Zarin

FORTHCOMING IN 2023

Blue
Derek Jarman

Mad about Painting
Katsushika Hokusai

Strange Impressions
Romaine Brooks

Published by
David Zwirner Books
529 West 20th Street, 2nd Floor
New York, New York 10011
+ 1 212 727 2070
davidzwirnerbooks.com

Editor: Elizabeth Gordon
Editorial Coordinator:
Jessica Palinski
Proofreaders: Anna Drozda,
Michael Ferut
Design: Michael Dyer / Remake
Production Manager: Luke Chase
Color separations: VeronaLibri,
Verona
Printing: VeronaLibri, Verona

Typeface: Arnhem
Paper: Holmen Book Cream, 80 gsm

Publication © 2022
David Zwirner Books

Introduction © 2022
Lauren O'Neill-Butler

The selection of texts by
Romaine Brooks is taken from
her unpublished typescript
manuscript "No Pleasant Memories,"
held in the Archives of American
Art, Smithsonian Institution,
Washington, DC.

p. 5: Smithsonian American Art
Museum, Washington, DC.
Photo: Smithsonian American Art
Museum, Washington, DC/
Art Resource, NY
pp. 22–23: Collection des Musées de
la Ville de Poitiers et de la Société
des Antiquaires de l'Ouest.
Photo © Musées de Poitiers/
Christian Vignaud

ISBN 978-1-64423-082-4

Library of Congress
Control Number: 20222912919

Printed in Italy

David Zwirner Books

ekphrasis